Keys to Painting
Trees &
Foliage

EDITED BY RACHEL RUBIN WOLF

David & Charles

The material in this compilation appeared in the following previously published North Light Books and appears here by permission of the authors. The initial page numbers given refer to pages in the original work; page numbers in parentheses refer to pages in this book.

Dews, Pat. *Creative Discoveries in Watermedia* ©1998. Pages 76-79 (40-43), 82-87 (34-39).

Heim, Dawn McLeod. *Step-by-Step Guide to Painting Realistic Watercolors* ©2000. Pages 104-112 (44-52).

Johnson, Cathy. *Painting Watercolors*. First Steps Series ©1995. Pages 46-47 (22-23), 50-51 (24-25).

Leland, Nita. *Exploring Color* ©1998. Pages 54 (53), 55 (56), 58 (57), 76 (54), 87 (55).

Macpherson, Kevin D. *Fill Your Oil Paintings With Light & Color* ©1997. Pages 36-37 (116-117), 96-97 (6-7), 98-99 (104 -105), 102-103 (102-103), 130-137 (118-125).

Maltzman, Stanley. *Drawing Nature* ©1998. Pages 16-25 (8-17), 32-35 (18-21), 84-91 (74-81).

Nice, Claudia. *Creating Textures in Pen & Ink With Watercolor* ©1995. Pages 84 (4), 108-115 (58-65).

Rocco, Michael P. *Painting Realistic Watercolor Textures* ©1996. Pages 104-105 (28-29).

Simandle, Marilyn, and Lewis Lehrman. *Capturing Light in Watercolor* ©1997. Pages 106-107 (26-27).

Szabo, Zoltan. *Zoltan Szabo's 70 Favorite Watercolor Techniques* ©1995. Pages 64-71 (82-89), 74-75 (92-93), 84-85 (90-91).

Wolf, Rachel. *The Acrylic Painter's Book of Styles & Techniques* © 1997.Pages 20-27 (94-101), 62-67 (106-111).

Wolf, Rachel. *Painting the Many Moods of Light* ©1998. Pages 12-19 (66-73), 26 (3), 58-61 (30-33), 80-83 (112-115).

A DAVID & CHARLES BOOK

First published in the UK in 2001
First published in the USA in 2001 by North Light Books, Cincinnati, Ohio

Copyright © Rachel Wolf 2001

A catalogue record for this book is available from the British Library.

ISBN 0 7153 1246 4

Printed in China by Regent Publishing Services Limited for David & Charles.
Brunel House Newton Abbot Devon

Metric Conversion Chart

To Convert	To	Multiply by
Inches	Centimeters	2.54
Centimeters	Inches	0.4
Ounces	Grams	28.4
Grams	Ounces	0.04

Edited by James Markle
Page makeup by Ben Rucker
Production coordinated by Emily Gross

ACKNOWLEDGMENTS

The people who deserve special thanks, and without whom this book would not have been possible, are the artists and authors whose work appears in this book.

Howard Carr

Gil Dellinger

Pat Dews

Brad Faegre

Dawn McLeod Heim

William Hook

Cathy Johnson

Lewis Barrett Lehrman

Nita Leland

Kevin Macpherson

Stanley Maltzman

Claudia Nice

Joseph Orr

Donald W. Patterson

Stephen Quiller

Michael P. Rocco

Mary Jane Schmidt

Marilyn Simandle

Zoltan Szabo

Gwen Tomkow

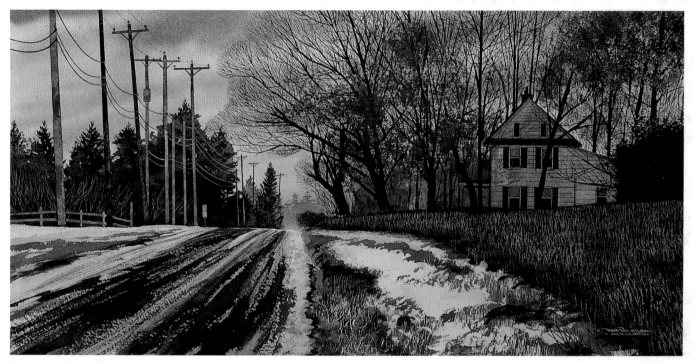

DONALD W. PATTERSON
Ridge Road
Watercolor
12" × 24" (30cm × 61cm)

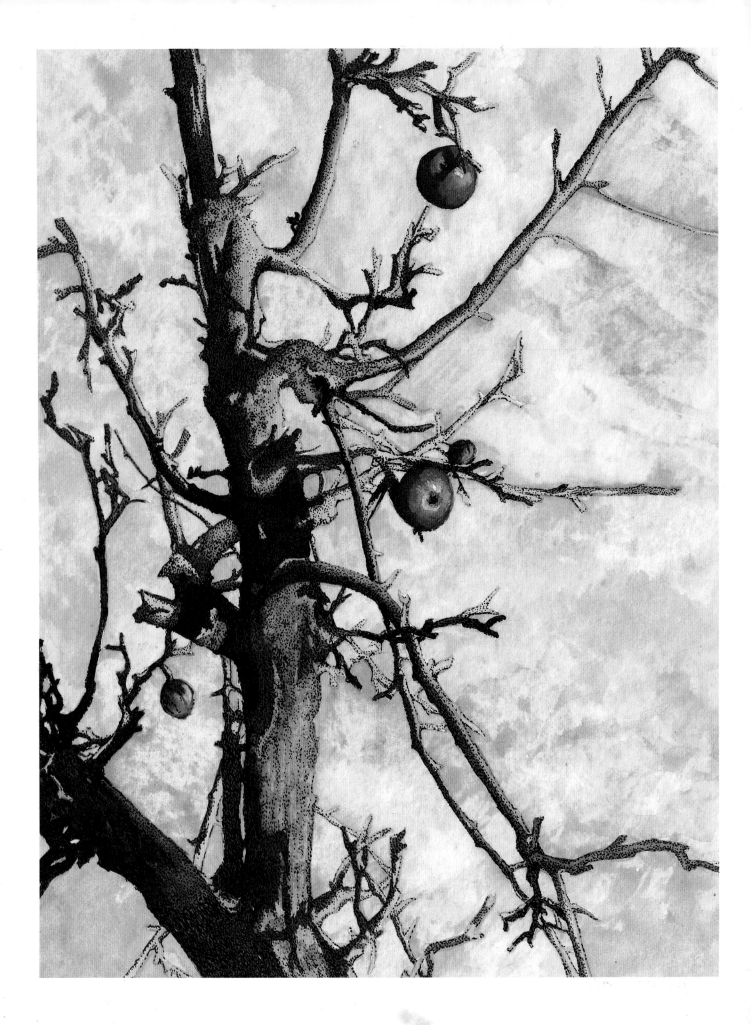

TABLE OF CONTENTS

INTRODUCTION 7

CHAPTER ONE

Drawing Trees & Foliage 8

- The Proper Way to Hold a Pencil
- Pencil Values
- Shading Methods
- Cross-Hatching
- Carpenter's Pencil
- Blending
- Thumbnails
- Balancing Elements
- Horizon Lines

CHAPTER TWO

Painting Trees 22

- Simple Tree Shapes
- A Variety of Tree Shapes
- Tree Bark
- Grasses
- Mix an Assortment of Greens
- Demonstration: Watercolor—Bare Winter Trees
- Demonstration: Oil—Painting Mountain Pines
- Fun Techniques for Painting Trees
- Demonstration: Mixed Medium—Create Trees Through Spray Painting
- Correcting With Collage

CHAPTER THREE

Painting Foliage & Grasses . . 44

- Demonstration: Watercolor—Realistic Autumn Leaves
- Break Away From Tube Greens
- Complementary Colors for Foliage
- Try Bold Bright Foliage Colors
- Demonstration: Pen and Ink—Leaf Textures in Pen and Ink
- Weeds and Grasses
- Moss and Ferns
- Lichen
- Mushrooms
- Demonstration: Watercolor—Paint Grasses and Reeds
- Demonstration: Watercolor—Close-Up: Grasses and Reeds

CHAPTER FOUR

Winter Works Magic on Trees & Foliage 74

- Drawing Trees in Light Snow
- Techniques for Showing Heavy Snow
- Demonstration: Graphite Pencil—Drawing a Snowy Landscape
- Drawing Tree-Covered Mountains
- Snow on Trees
- Drawing Winter Leaves
- Watercolor Shadows on Snow
- Sunlight on Snow
- Warmly Lit Snow
- Falling Snow
- Trees in Heavy Snow
- Young Spruce in Snow
- Ice on Trees
- Frost on Trees
- Mist
- Demonstration: Acrylic—A Wooded Snow Scene

CHAPTER FIVE

Painting Trees "En Plein Air" & "En Studio" 102

- Nature and You
- Demonstration: Oil—En Plein Air in Winter
- Demonstration: Acrylic—A Snow Scene From a Photograph
- Demonstration: Pastel—Sunlight Penetrating a Morning Fog
- Mood Changes From the Outdoors to the Studio
- Oil Sketches Become Studio Paintings

INDEX 126

CLAUDIA NICE
Winter Apples
Watercolor and India Ink
10" × 7" (25cm × 18cm)

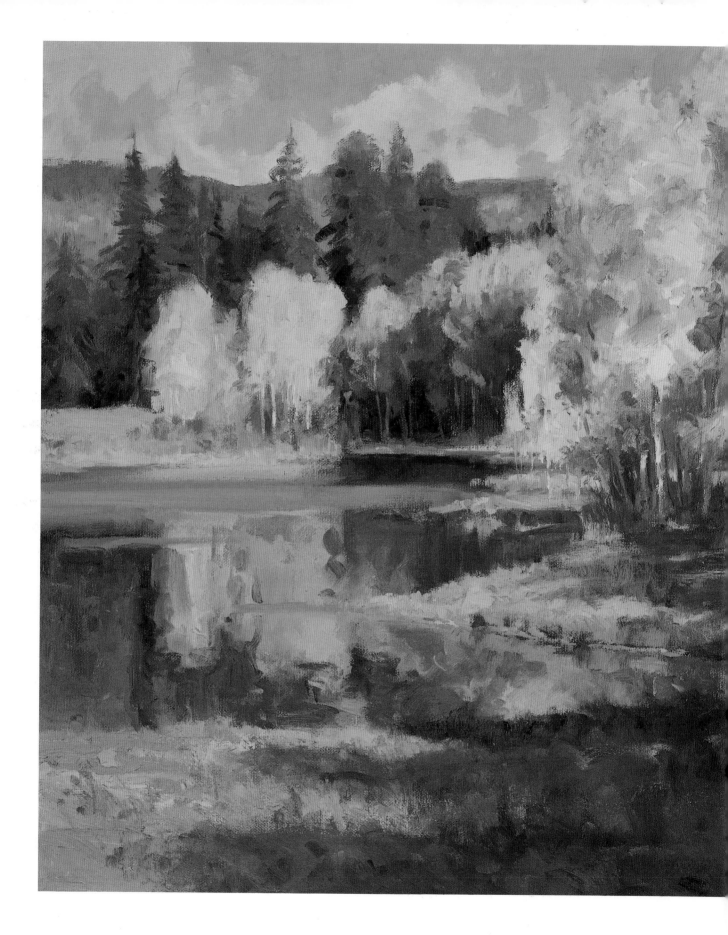

INTRODUCTION

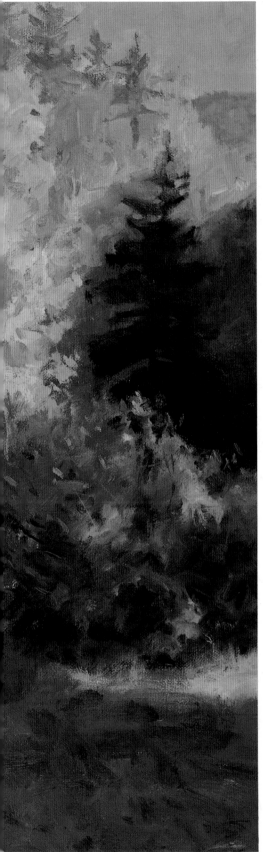

Unless Death Valley is your favorite vacation place, trees and foliage are probably the central focus of most of the landscape painting that you do. It is hard to imagine this Earth without the lush and beautiful coif of green that covers much of the globe's land mass. But for the artist this gorgeous green, or perhaps the intriguing pattern of bare winter branches, can pose a formidable problem when one attempts to recreate it on paper or canvas.

This book brings together some of today's best landscape artists in a variety of painting and drawing mediums to help you discover new ways to visually describe the natural arboreal beauty around us. Art mediums include pencil, charcoal, watercolor, pen and ink, oil, acrylic and pastel. You'll learn from Zoltan Szabo watercolor techniques for painting tree shadows on snow and ice on trees. Stanley Maltzman shows you how to sketch a tree-covered mountain in pencil. Dawn McLeod Heim shows how to paint realistic autumn leaves in watercolor. This is just a sampling of the many techniques and demonstrations you will find inside. The artistic secrets of these nineteen artists will help you bring your own landscape paintings to life.

KEVIN MACPHERSON
Full Glory
Oil
20" × 24" (51cm × 61cm)

Drawing Trees and Foliage

The Proper Way to Hold a Pencil

The artwork on pages 8–21 was created by Stanley Maltzman.

Holding your pencil as you would if you were writing is ideal for doing detailed drawing and small works.

Hold your pencil like this when sketching or drawing outdoors. This position gives you more freedom, enabling you to move your whole arm.

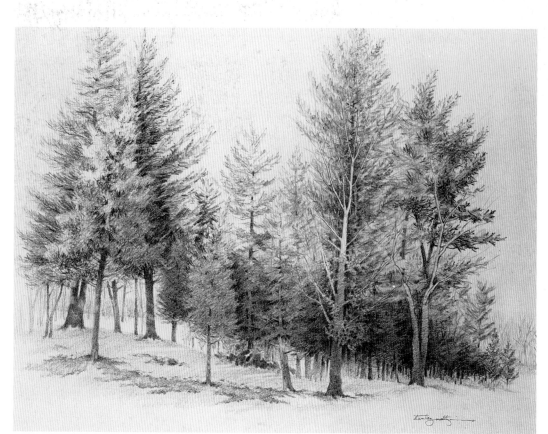

This drawing was started by holding the charcoal pencils in the manner for doing quick sketching. About two-thirds from finishing, the position was changed to holding the pencil for tightly detailed work.

STANLEY MALTZMAN
Stand of Pines
Charcoal pencils
on Whatman paper
18" × 22"
(46cm × 56cm)
Collection of John
and Judy Jester

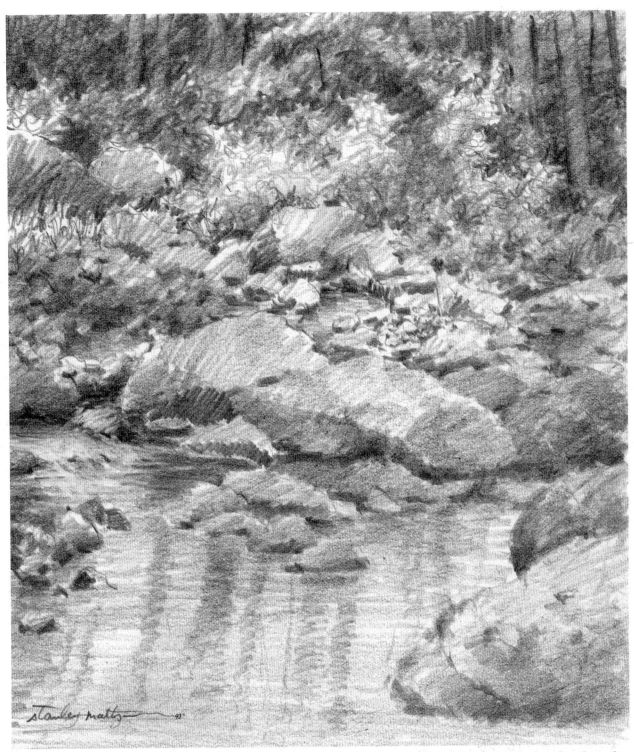

This drawing was executed holding the pencil for quick sketching. The pattern of darks and lights in the woods and on the rocks with the reflections in the water really catches your eye.

STANLEY MALTZMAN
Catskill Creek
Graphite pencil
8" × 7" (20cm × 18cm)

Pencil Values

Value refers to the range of lights and darks your pencil can produce, they range from a dark black to a light gray and all the shades in between. You can experiment with various types of pencils to discover what values they produce. Observe which lead will give you the richest black or a nice gray. You don't have to memorize everything a particular pencil will accomplish: Just get a good working sense of the range of pencil values.

These values were created by the following pencils:

A Carpenter's pencil, 4B lead
B ¼" (6mm) graphite lead, no. 2, in a mechanical pencil
C Woodless pencil, 6B
D Mechanical pencil, 2H lead
E Wood encased graphite pencil, H
F Water-soluble pencil, very soft

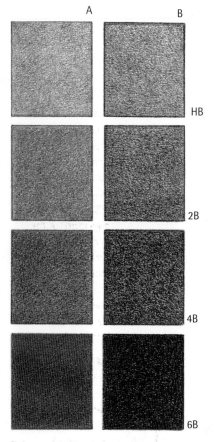

Column A is graphite. Column B is charcoal. Even though they are the same pencil numbers, notice the slight difference in the values.

Row A is 2B graphite pencil. Row B is a 2H graphite pencil. Notice the difference in richness.

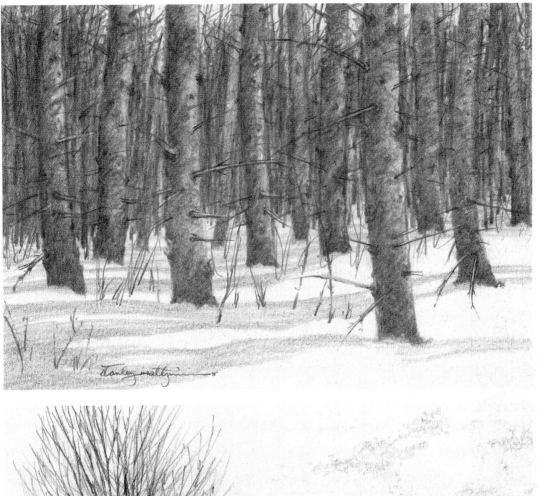

This drawing was created using one pencil, an ebony jet-black graphite pencil. Notice how the values are fairly close, giving the impression of a densely wooded area.

STANLEY MALTZMAN
Winter Woods
Graphite pencil
6" × 8"
(15cm × 20cm)

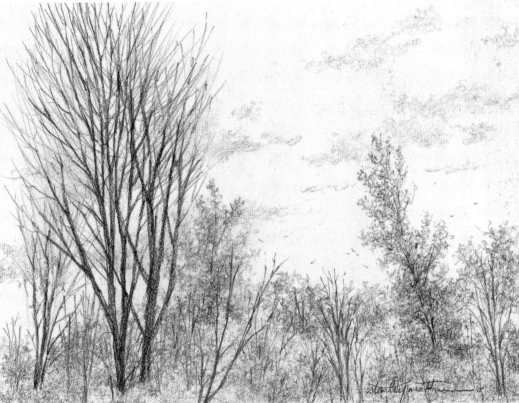

Several different charcoal pencils were used in this drawing to capture the many values of autumn colors. HB general charcoal was used for the darker foliage; 2B, for the smaller trees without foliage. Last, a 4B was used for the darkest bare-branched maple.

STANLEY MALTZMAN
Autumn Trees
Charcoal on Strathmore Alexis paper
6" × 7"
(15cm × 18cm)

Shading Methods

Your pencils can help you create many varied lines and textures: thick or thin lines, hard or soft lines, and any manner of shading. The methods you use to achieve them are called techniques. With work and time, these techniques evolve into your own style. Try the following methods of shading with different papers and pencils. The key is to experiment; remember that mistakes help you to learn.

CIRCULAR SHADING

This method starts at the right side of the paper with small, circular shapes. As you continue shading toward the left, the circles merge and disappear into a beautiful, rich tone. Use this type of shading to render intricate studies like the drawing below. It is a type of eye exercise that can help you see the landscape as shapes of lights and darks.

Circular Shading

STANLEY MALTZMAN
Yesterday
Carbon pencil on Whatman paper
6" × 8" (15cm × 20cm)

ANGULAR BUILDUP

These sketches of a tree and fence show two ways of rendering a subject with angular lines. In the sketch at left, the pencil is held in the position for sketching outdoors. As you build the tone, the preliminary lines disappear, and your darks and lights emerge—an excellent method for outdoor sketching. The right-hand sketch is a more decorative type of angular rendering, but one must be careful not to let the line pattern distract from the picture.

The drawing below was created using the angular buildup. Not much was added to the preliminary shading in the background tree. You can see that the shading was carried further to build up the darks of the bark in the tree in front.

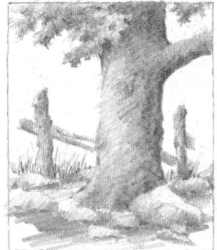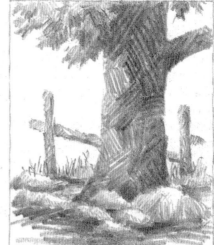

Angular Buildup

STANLEY MALTZMAN

Tentacles

Charcoal

23" × 31" (58cm × 79cm)

Collection of Mr. and Mrs. George Schiele

This drawing was executed with a ¼" (6mm) charcoal stick in a mechanical pencil. The pine needles were rendered with a B charcoal pencil.

Cross-Hatching

Cross-hatching is a technique that uses two series of parallel lines running in different directions. It is a process more suited to pen and ink because of the many fine lines, but with planning and patience, it can be done with a graphite pencil.

The examples to the right and the drawing below, done with an HB general graphite pencil, demonstrate the cross-hatching technique.

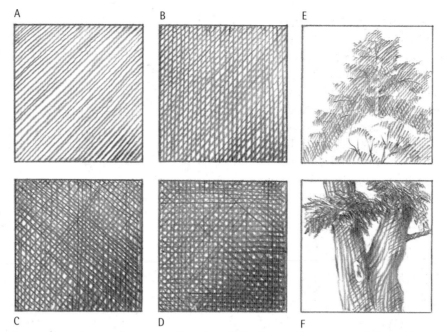

Box A shows the starting process. Note that all the diagonal lines are parallel to each other. Box B shows the addition of vertical lines. Notice that with just the vertical set of lines added, the value has deepened. In box C the lower-right corner is made darker by increasing the pressure at the bottom of some of the strokes. With the addition of more diagonal and horizontal lines, the box D continually becomes darker. Boxes E and F show examples of cross-hatching applications.

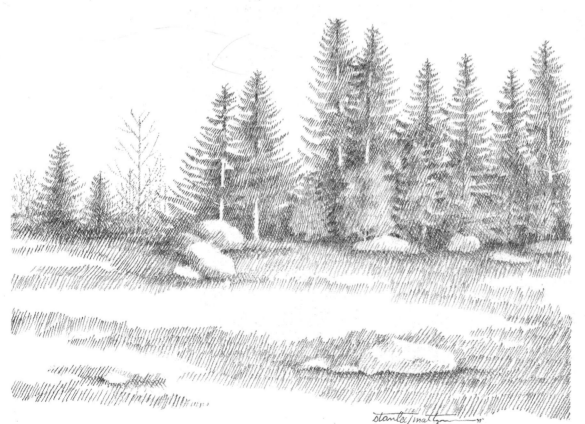

Cross-hatching can be used to create a wide variety of shades and values.

STANLEY
MALTZMAN
Pines
Graphite pencil
on two-ply
Strathmore paper
6" × 8"
(15cm × 20cm)

Carpenter's Pencil

The carpenter's pencil is another wonderful sketching tool to use in conjunction with the regular pencils. As seen in these sketches, values are indicated with simple, broad strokes.

For drawings with heavy foliage, such as the one below, use the same technique with more modeling. To make the finer lines, hold the pencil sideways, using the edge of the lead.

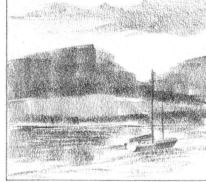

Add darks by pressing harder with the lead.

A Derwent carpenter's pencil (4B) creates additional blacks.

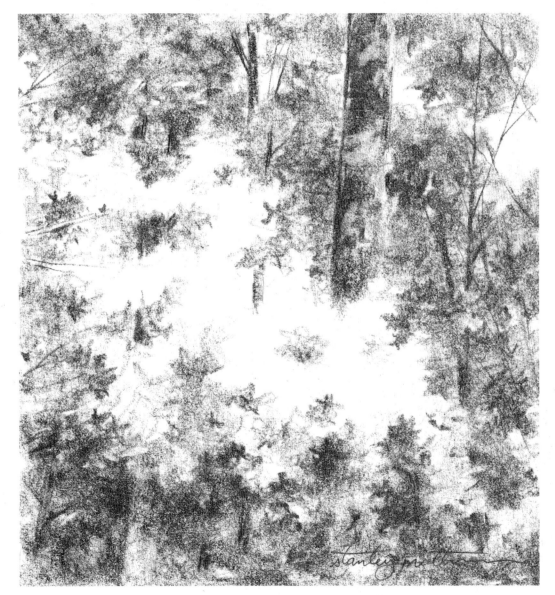

STANLEY MALTZMAN
Hunter Mountain Foliage
Carpenter's pencil
7" × 6"
(18cm × 15cm)

Blending

The drawings on these two pages demonstrate some of the numerous ways to work with stomps (stumps) and tortillions (tortillons). These cigar-shaped rolled paper blending tools are great to work with. Quite a few drawings have been salvaged with their help.

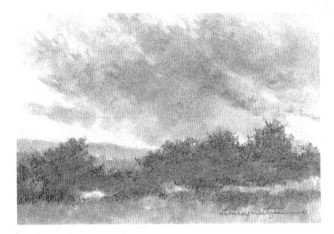

This drawing was executed mostly with a chamois stomp. Put some charcoal powder on a separate piece of paper (you should save the powder from charcoal pencil sharpenings), then roll part of the stomp's point in the powder. Rub it lightly on a piece of scrap paper so it won't be too strong in value. Put the distant mountains in first, then the large dark mass of trees. With what is left on the stomp, model the field. Roll it again in the charcoal powder for the darks in the foreground and the clouds. Take a clean tortillion and a kneaded eraser and remove some of the tone in the upper left corner and at the baseline of the trees. Add a very gentle touch of 2B charcoal pencil along the tree line and the base—just enough to finish the drawing.

STANLEY MALTZMAN
Evening Clouds
Charcoal on Strathmore two-ply bristol board
3" × 5" (8cm × 13cm)

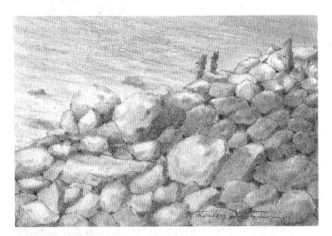

Sketch this drawing with a 4B charcoal pencil. Using the left-over charcoal from the drawing, model the rocks with a small tortillion, adding darks and emphasis where needed. Model the water with a large stomp, then add a few light lines with an HB charcoal pencil to complete it.

STANLEY MALTZMAN
Along the Hudson
Charcoal on Strathmore two-ply bristol board
3" × 5" (8cm × 13cm)

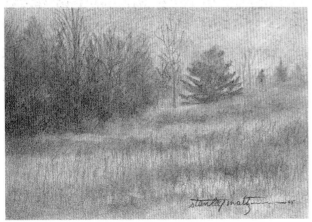

Cover the whole background with one value of charcoal, then come back with additional darks to build up the tree mass. With an HB charcoal pencil, add just a little more suggestion of trees to give the desired effect.

STANLEY MALTZMAN
Evening Fog
Charcoal on Strathmore two-ply bristol board
3" × 5" (8cm × 13cm)

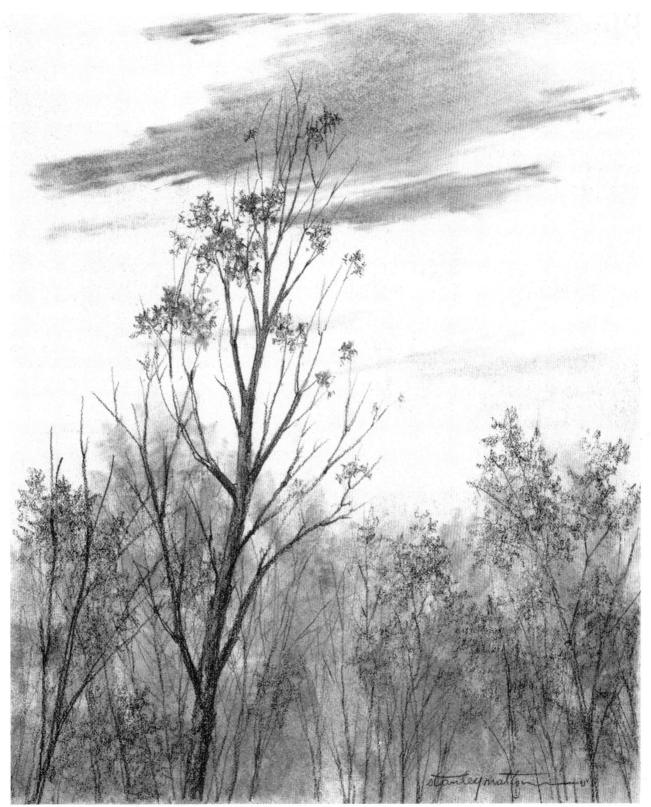

Stomp the drawing with charcoal powder first, then model the trees
and foliage on top of the stomping with a charcoal pencil. When
using a stomp, avoid scrubbing the paper too hard, as it will cause
the charcoal already laid down to be less pliable.

STANLEY MALTZMAN
Season's End
Charcoal on Strathmore two-ply
bristol board
8" × 7" (20cm × 18cm)

Thumbnails

Thumbnails are a wonderful way to get your creative energies charged up. This is the time to work out your picture—now, before you start the finished drawing. Your key thought should be to simplify. Remember, you are only looking for ideas. Don't get involved with details at this stage, and keep your thumbnails small—postcard–sized or smaller. Build your composition by including interesting shapes, determining your values and deciding on your center of interest. Do you want a low horizon or a high horizon? That tree looks like it is growing out of the roof of the house: Move it. You can move, eliminate or add whatever elements will help make your picture. This is the purpose of thumbnails: getting your ideas down on paper where you can see them. You will find that one idea will lead to another, and before you realize it, you will have a sheet full of ideas. Pick out what you feel is your best thumbnail, or combine the best ideas from a few sketches.

You should arrange all your ideas into one thumbnail, which will become your working sketch. You may want to enlarge it to help you see things more clearly. Go right ahead—working out all the problems now will make your final drawing easier and more fun to do. Save your thumbnails: They can become an excellent reference file, and some of the beauty you have captured in these quick little sketches will inspire you to create other drawings.

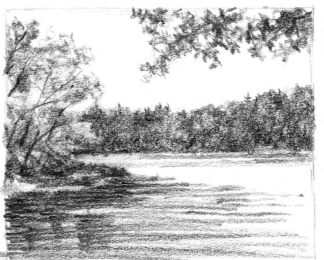

A horizontal format shows a small shoreline on the left and a large tree line across the lake. The composition looks a little unbalanced, so the overhead branch is added. Not too bad, but the left side is still troublesome: Something is missing.

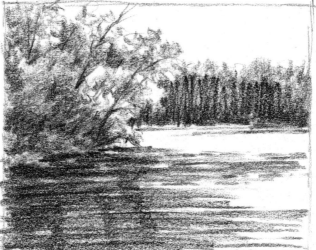

This drawing includes more shoreline, and the trees hanging over the water create interesting reflections. The horizon line is raised and the trees across the lake are brought in closer. Notice how moving the elements around quickly changes the sketch.

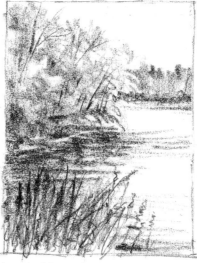

A vertical format lets you try another design. The weeds and cattails are added for more interest.

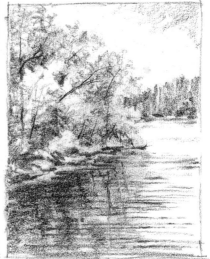

Finally, the right elements are put together successfully to make an interesting composition.

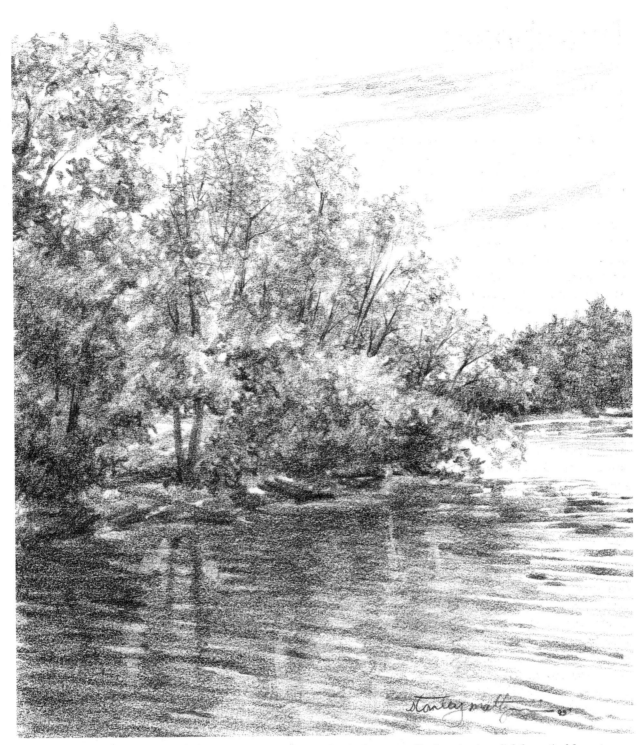

Here is the finished drawing composed from the thumbnails on the previous page. By changing to a slightly vertical format, more of the shoreline with a greater variety of tree shapes is included. The reflections and darks in the water create interesting patterns of design. The trees in the background carry the eye back to the left.

STANLEY MALTZMAN
Lakeside
Graphite pencil on Strathmore Alexis paper
8" × 7" (20cm × 18cm)

Balancing Elements

No matter how many beautiful elements you have in your picture and how wonderfully the paint or pencil is applied, it will never be successful if the elements are not in harmony with one another—negative spaces balancing positive spaces, the horizon line placed above or below the center of your paper, etc.

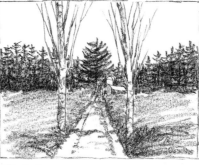

Mistake

Here are some common mistakes to avoid. The horizon line divides the picture exactly in half. The large pine tree and the background trees are uninteresting because of their look-alike shapes, as are the two trees in the foreground. The road in the center leads your eye directly to the barn. Each element is centered and balanced with equal shapes that create boredom.

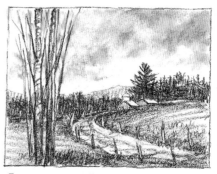

Improvement

This drawing takes the same elements and creates interest by lowering the horizon line and changing the shape of the forest. The mountains give the drawing more depth. The large pine is moved to the right and is counterbalanced by the foreground trees on the left, providing a good example of a large mass and a smaller one creating a balance of elements. The curving road takes your eye to the barns, and though they are partially hidden, they are the center of interest. An object does not have to be overbearing to be the center of interest—the more subtle, the more interesting.

Mistake

This sketch is divided horizontally into three equally dominant parts: the foreground, the trees and the sky. The pine trees are the same height and character, guarding the edges. The road leads your eye to the woods, but not to any center of interest.

Improvement

This drawing also has horizontal divisions, but each one is a different shape and weight. The apple trees in the foreground are silhouetted against the pine woods, making them stand out and become the center of interest. Your eye focuses on the apple trees, then moves to the left because of the perspective in the trees. You follow the trees and mountain up to the clouds, then back to the mountain and the trees on the right. The elements are in harmony; thus, you have a pleasing sketch.

Horizon Lines

HIGH HORIZON

As you saw on the previous page, a horizon line that cuts right across the middle of your picture can lead to a static, boring composition. Strive for unequal divisions and asymmetrical placement of the various elements in your drawing, which you balance with size, values or perspective. In this sketch, a high horizon line gives you the opportunity to produce a more interesting picture. The trail on the right is balanced by the field and dark area on the left. The trees lead you to the vanishing point, which is the center of interest, and to where the trail disappears beyond the tree line. The mountain suggests that something is going on beyond the tree line. A little mystery creates more interest.

Using a high horizon gives you the opportunity to do more with the foreground; for example, you could create a large tree up front to add more depth to the picture.

LOW HORIZON

A low horizon line gives you the room to develop wonderful skies, to do something interesting with dramatic cumulus or cirrus clouds flying across the vast space. Notice in this sketch that more of the mountain is included. Remember that as you shift your working position from sitting to standing, the horizon line will also change.

Don't always place your horizon line in the same area on your paper. Just as your point of view changes as you shift your position, so should your horizon line move up or down depending on which elements you want to emphasize.

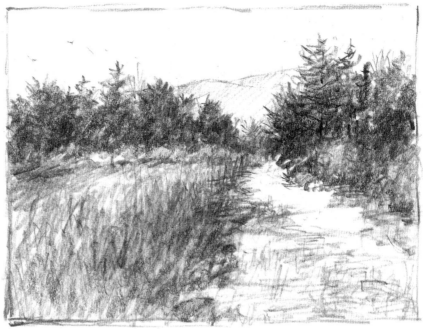

High Horizon
Using a high horizon line is another way to make an interesting composition; it also allows you to place many more elements in the foreground. Here, the trail on the right is balanced by the field on the left. The trees lead you to the center of interest where the trail disappears beyond the tree line.

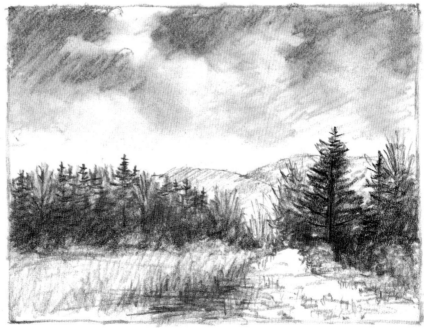

Low Horizon
The beauty of using a low horizon is that it leaves you room to work with dramatic skies and clouds, which is always great fun. It also lets you include many details in the middle ground, while giving the impression of vast distances.

Painting Trees

Simple Tree Shapes

As watercolorist Cathy Johnson knows, almost every landscape painting has to deal with trees in one way or another. Paint a semigeneric tree from your imagination, just to get you started. Watch for ways to use light and shadow to give form to your painted tree. All the art on pages 22–25 was completed by Cathy Johnson.

> **Tip** TREE TRUNK COLOR
> Remember that in life, tree trunks are very seldom warm brown and almost never uniform in color or value. They're more of a grayish color; mix Burnt Umber or Burnt Sienna with Ultramarine Blue in various mixtures to suggest trunks. Use value to suggest light, shadow and form.

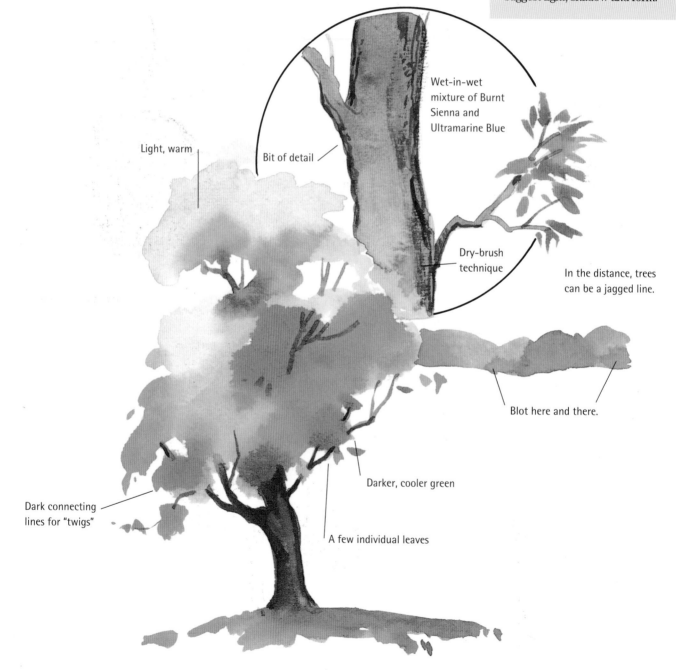

Light, warm

Bit of detail

Wet-in-wet mixture of Burnt Sienna and Ultramarine Blue

Dry-brush technique

In the distance, trees can be a jagged line.

Blot here and there.

Dark connecting lines for "twigs"

Darker, cooler green

A few individual leaves

A Variety of Tree Shapes

Trees come in a variety of forms—a pine tree doesn't look anything like a palm, and an oak has a different silhouette from an elm. Good observation will lead to a happy diversity in your work; notice the many shapes and sizes and colors. Try out different tree shapes, using several different brushes.

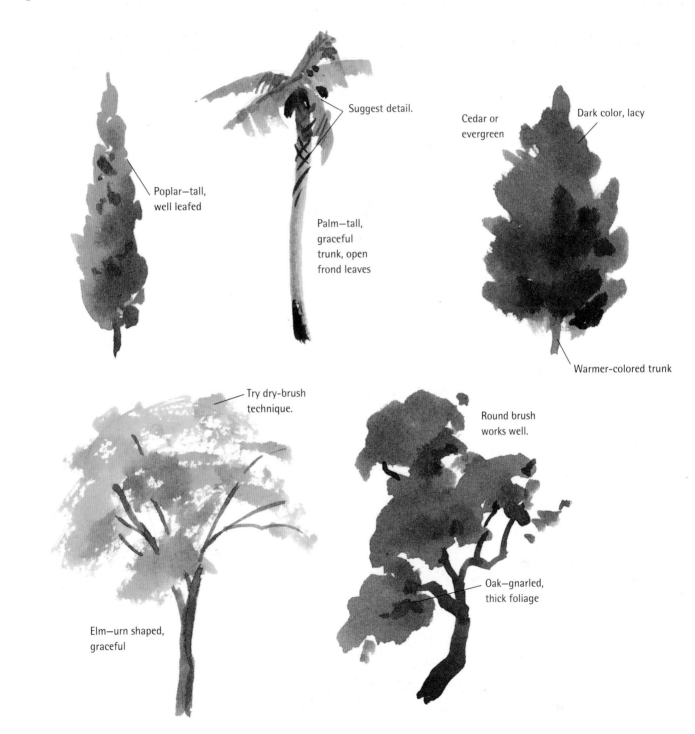

Suggest detail.

Poplar—tall, well leafed

Palm—tall, graceful trunk, open frond leaves

Cedar or evergreen

Dark color, lacy

Warmer-colored trunk

Try dry-brush technique.

Round brush works well.

Elm—urn shaped, graceful

Oak—gnarled, thick foliage

Tree Bark

Notice how much detail you don't need at a distance—a cool, varied wash will do. Add a bit more detail— perhaps drybrush it—as you advance, and then paint as much as you like for foreground trees.

There's no need to settle for generic tree bark unless that's what you want. Notice the differences, and explore ways to suggest these textures. Here, a young oak grows next to a wild plum. See how different they are?

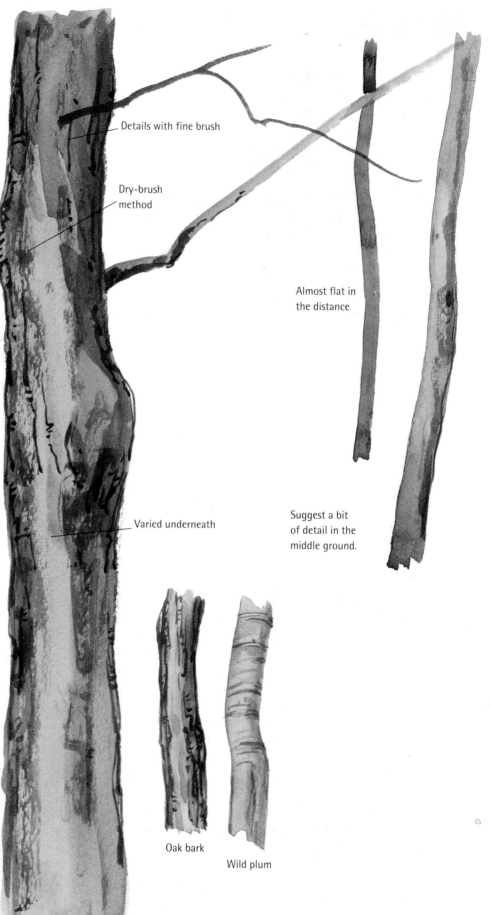

Details with fine brush

Dry-brush method

Almost flat in the distance

Add as much as you like, close-up.

Varied underneath

Suggest a bit of detail in the middle ground.

Oak bark

Wild plum

Grasses

Trees are normally situated amidst grasses and weeds. Try several versions, from short, spiky grasses painted in over a smooth wash to tall, rough grasses. First, try out some simply painted short grass—the type you see in your lawn or park.

Remember, all grasses aren't green: Depending on the season or degree of rain, they may be any shade from green to gold, light to dark.

Notice how little detail you actually need to paint distant grasses. You can't see individual blades except in the foreground.

Trees usually darker

Shortest strokes in distance

Wet-in-wet

Suggest different textures.

Fan brush and spatter

Blot

Short, upward strokes

Mix in green or other colors for interest.

Not all grasses are green—here a prairie has turned golden.

Longer strokes with fan brush suggest tall grass.

Mix an Assortment of Greens

It seems as if greens are every watercolorist's bugaboo. Yet you really can't ignore them in trees and foliage. So you buy tubes and tubes of greens that don't work. Why? Because using green straight from the tube can make all your greens look alike—not very interesting. How do you create believable, appealing, exciting greens? Marilyn Simandle suggests limiting those tube greens. You can easily mix loads of warm, cool, light, dark, bright or grayed greens with colors you already have on your palette. Look at Marilyn's examples on these pages, then try some for yourself. You can create infinite variations with different proportions of each pair of colors. Blend them wet-in-wet, and see your washes come to life. You can even add a third color, but avoid mixing more than three. The examples on pages 26–27 were completed by Marylin Simandle

Manganese Blue and Cadmium Yellow

Manganese Blue and Raw Sienna

Manganese Blue and Burnt Sienna

Manganese Blue and Cadmium Orange

Cobalt Blue and Raw Sienna

Cobalt Blue and Cadmium Orange

Cobalt Blue and Cadmium Yellow

French Ultramarine and Raw Sienna

French Ultramarine and Cadmium Orange

French Ultramarine and Burnt Sienna

Antwerp Blue and Raw Sienna

Antwerp Blue and Burnt Sienna

Antwerp Blue and Cadmium Orange

Antwerp Blue and Cadmium Yellow

French Ultramarine and Cadmium Yellow

Bare Winter Trees

MICHAEL P. ROCCO

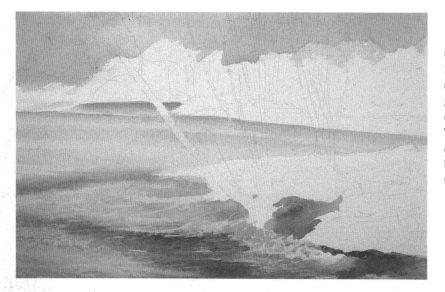

1 Paint the sky area onto the dry sheet. Do not pre-wet the paper for such a small portion. Bring the color wash down far enough below the tree line so it can be seen in the final stages. Paint the middle ground and foreground similarly, blending deeper values while this area is still damp. These values represent changes that occur on the frozen pond. Occasionally, drag your brush across the paper to give texture to the irregular ice.

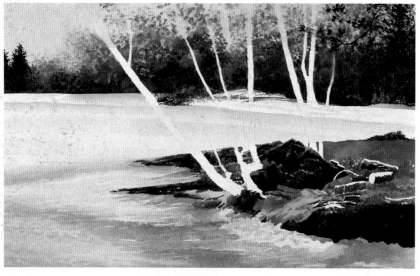

2 For the sparse foliage of the background trees, use a great deal of stippling and dry-brush technique. Stippling more densely and in a darker color in some locations gives a fuller effect creating overlapping branches. As the foliage and trees come closer to the pond, paint the color more solidly, with variations in hue, to avoid a flat look. Paint the point of land in the middle ground, establishing form, shapes and values. Leave the major tree trunks clear.

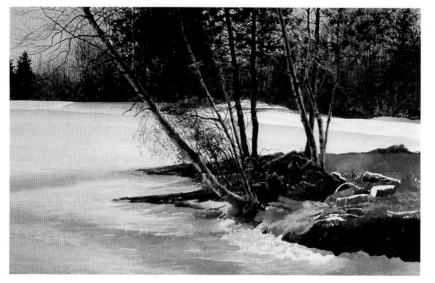

3 Use stippling to develop the background trees. Paint tiny branches against the sky in a pale color using a small, thin-haired brush. Paint heavier branches with a no. 2 round brush and a darker color. Stipple twigs and weeds on the point of land, then start painting the trees. Lay in all the light colors of the trunks, then add the darks, blending wet-in-wet at times for softness of form.

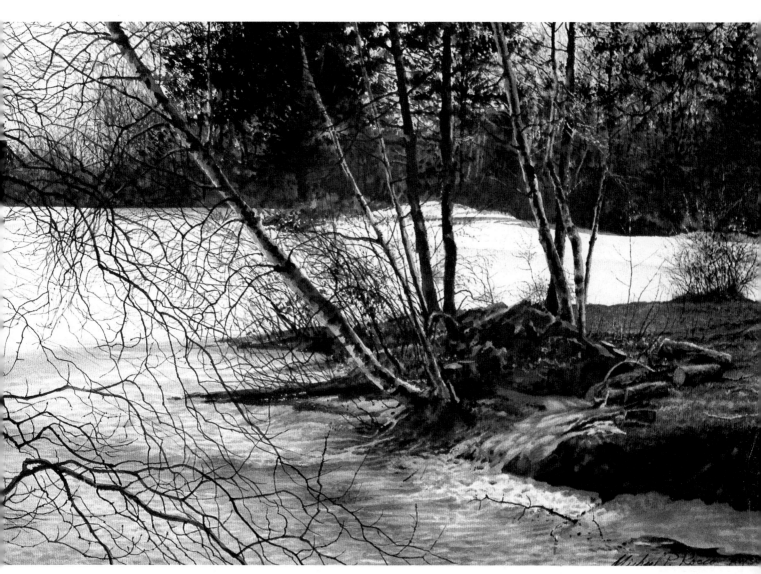

4 Overlay colors on the patch of deep orange in the middle ground to achieve a ground full of fallen leaves. Clean away some color for lighter leaves, adding shadows for definition. Scratch away color with a craft knife to give sparkle to some branches.

Work on the pond in the foreground, deepening its value and heightening the contrast relationship with the distant area. Paint in the rippled and irregular formation of the ice. In the left foreground area, paint branches in a rhythmic manner with a small, thin-haired brush.

MICHAEL P. ROCCO
Frozen Pond
Watercolor
14" × 21" (36cm × 53cm)

COLOR PALETTE
Burnt Sienna
Cerulean Blue
Chrome Orange
Hooker's Green Deep
Neutral Tint
Olive Green
Raw Umber
Sepia
Warm Sepia
Yellow Ochre

Painting Mountain Pines

HOWARD CARR

Imagine a late summer morning, with a cool, fast moving stream coming through a warm, comforting bank. At midday, most of the light comes from above. The weight of cool and warm colors must be equalized throughout the piece, relying on the revealing white top light to show those colors clearly.

1 TONE AND SKETCH
Tone the canvas with a warm wash of Alizarin Crimson and Sap Green. With a no. 2 filbert, sketch in the basic big shapes and composition with rough lines.

2 BLOCK IN THE DARKS
Block in the big, simple dark trees with Sap Green, Ultramarine Blue and a touch of Alizarin Crimson. Be sure to use a good-size brush for this part: It forces you to keep the block-in areas silhouetted and simple.

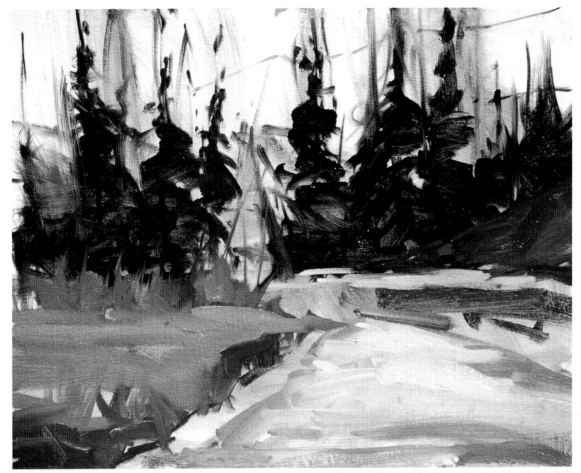

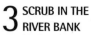

3 SCRUB IN THE RIVER BANK

Create a middle-value, warm-temperature neutral color using Yellow Ochre, Cadmium Orange and Alizarin Crimson for the riverbank. Paint this area with loose, fun brushstrokes.

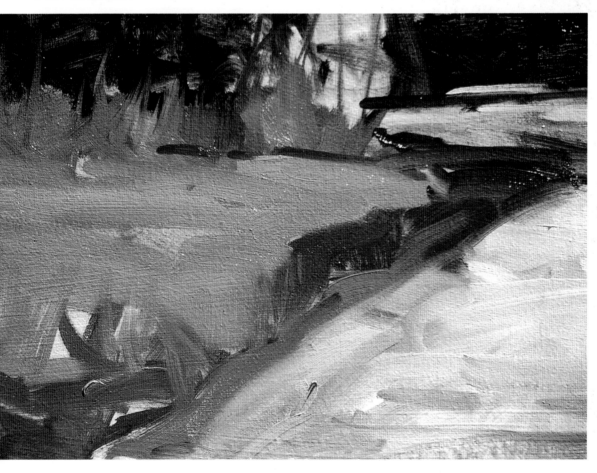

4 BRIGHT WATER

Add a strip of Cerulean Blue to indicate water. Keep the colors bright but relatively light, as the sun shines directly on these areas.

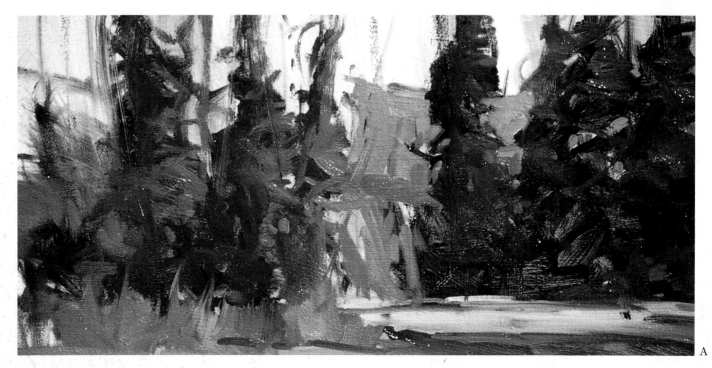

A

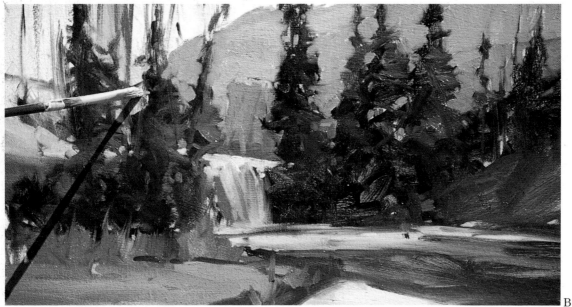

B

C

5 FIT IN THE BACKGROUND

There are three background areas:

A. The first, directly behind the trees, is warmer and lighter and has the hardest edges.

B. The middle hill is cooler, made up of Rose Violet with Viridian and softer edges.

C. The distant sky is carefully laid in with toned whites, including touches of warm yellow-pinks and Cerulean Blue.

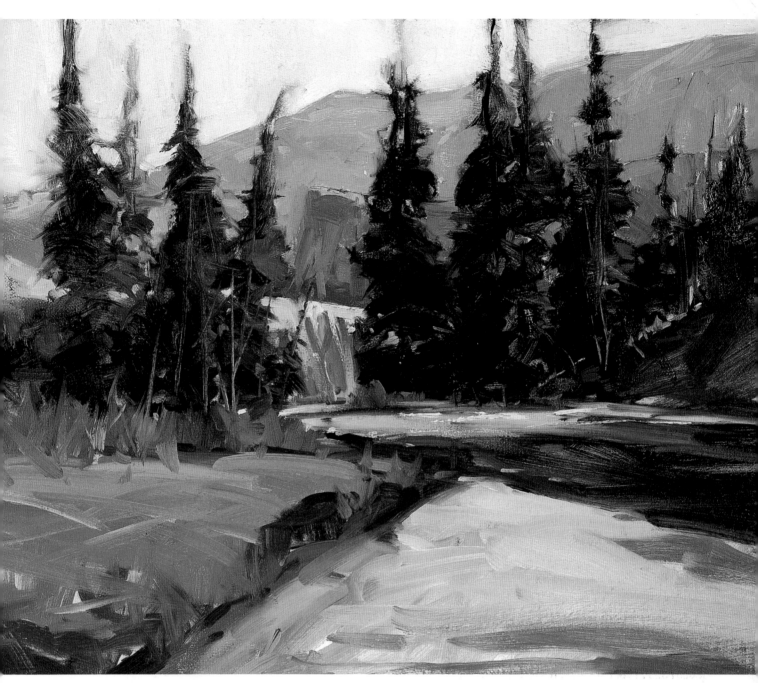

6 FINAL TOUCHES

Tie the painting together by softening some edges and adding highlights. Use your fingers as well as the brush to soften edges and blend, but don't overdo it: You don't want mud. Grab a clean brush, pick up a fair amount of cream color and, using the side of the brush, pull delicate strokes through the landscape. This helps tie the painting together and gives a nice balance of creative brushwork to those big, simple shapes you painted earlier.

HOWARD CARR
Landscape With Pines and River
Oil
20" × 16" (51cm × 41cm)

Tip SET THE MOOD AND SIMPLIFY
It can't be said enough: You must get excited about your subject! Simplifying your subject to broad areas of light and color helps you stay excited and involved, and therefore helps you convey the mood you want.

Fun Techniques for Painting Trees

Knowing there are lots of different ways to render a subject gives you great freedom. For example, watercolor paper can be resurfaced with a coat of gesso; you can cover your painting with dark colors and let some of the darks peek out later; you can add collage; you can cover some of your watercolor painting with acrylic medium and start again using acrylic; you can even crop and make new-sized paintings. Try anything, experiment and make your own discoveries. Having a mess to work on gives you courage. It's easy to think a painting can only get better—and if it gets worse, you've lost nothing. The artwork on pages 34–43 was created by Pat Dews.

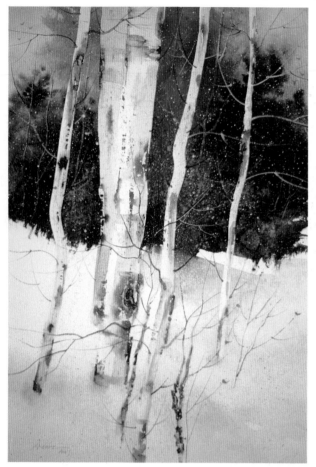

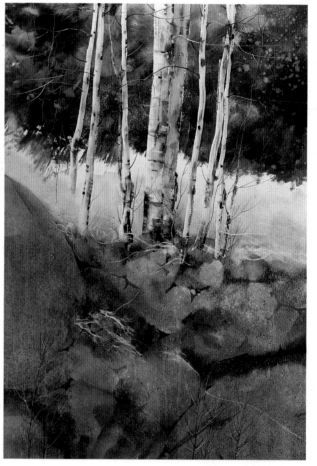

Use Mahogany to paint pink in the snow to symbolize light. Bleach spritzed on this area creates the sparkles of light. Use liquid masking fluid to mask out the trees.

PAT DEWS
Birch Light
Watercolor and ink on 140-lb. (300gsm) Arches paper
11" × 14" (28cm × 36cm)
Private collection

Use a fan brush to paint the background trees and liquid masking fluid to mask out the birch trees. Plastic wrap, waxed paper, alcohol and rice paper are used for texture.

PAT DEWS
Winter Light 6
Watercolor on 125-lb. (270gsm) Rives BFK paper
21" × 30" (53cm × 76cm)

PAPER

Use various papers for these demonstrations. Paper is only specified if it's germane to the particular technique. You should try many different papers so you can see what works best for you and because different papers work differently. Do not limit yourself to one particular paper. Part of becoming a better painter is to try new things. Don't tear up a piece of paper and discard it before you have tried everything!

Tip **NONTRADITIONAL COLOR**
More abstract paintings look abstract because of the use of nontraditional color. Remember that water, trees and rocks can be red, purple or green. You are the painter. You get to decide. In abstract work you can give a clue to your subject in the title. If the title is *Sea Breeze*, the viewer knows your purple, pink and orange wave is indeed a wave, and the viewer sees a new perspective.

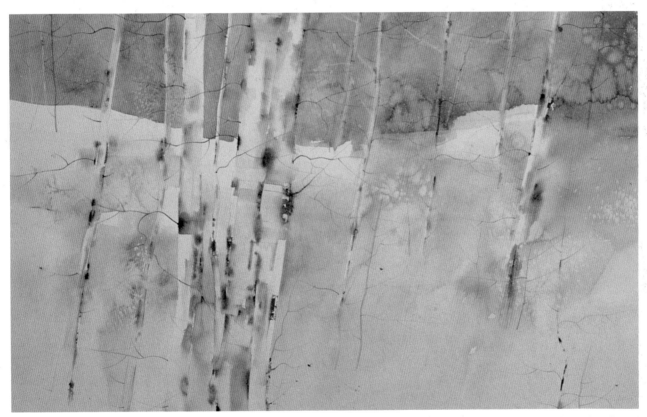

Do not use masking fluid for these birches; paint the area around them, leaving a negative space. Use a razor for modeling the trees, salt for texture and clean water spatters for water marks. The textures make it really seem like fresh snow.

PAT DEWS
Birch Essence
Watercolor on 260-lb. (555gsm) Arches cold-pressed paper
26" × 40" (66cm × 102cm)
Private collection

Create Trees Through Spray Painting

PAT DEWS

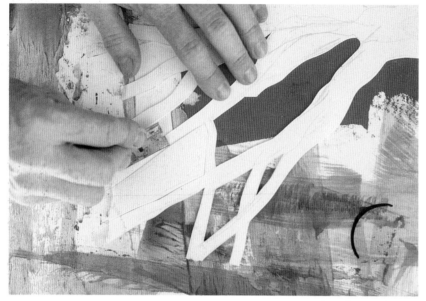

1 CUT A TEMPLATE
Draw a tree to cut for your template. Find a great live oak tree or other majestic tree. Grab a pencil and make a sketch.

2 PREPARE A BACKGROUND
Paint the background using a 2-inch (51mm) brush and Alizarin Crimson, Burnt Sienna, Cerulean Blue, Raw Sienna and Sap Green watercolors. You should feel free to choose any color you like.

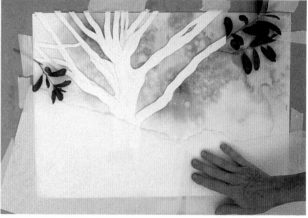

3 POSITION TREE AND LEAF TEMPLATES
Tape your templates in place over the background. Instead of artificial leaves, use real oak leaves.

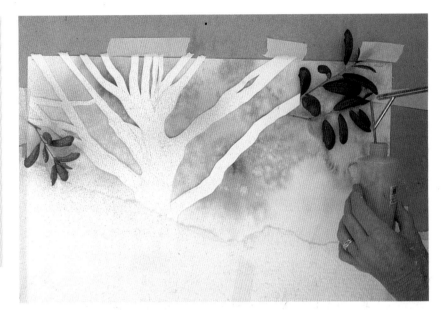

4 MASK AND SPRAY
Place a paper towel mask over the bottom portion of the paper. Use a mouth atomizer to spray Indian Yellow acrylic ink over the tree and leaves.

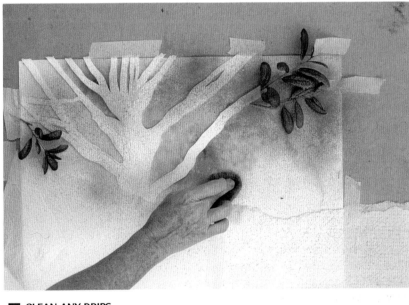

5 CLEAN ANY DRIPS
Gently tap with a natural sponge to catch any drips.

6 **OVERALL VIEW**
The painting is beautiful at this stage, but show more of the tree trunk so it's firmly rooted.

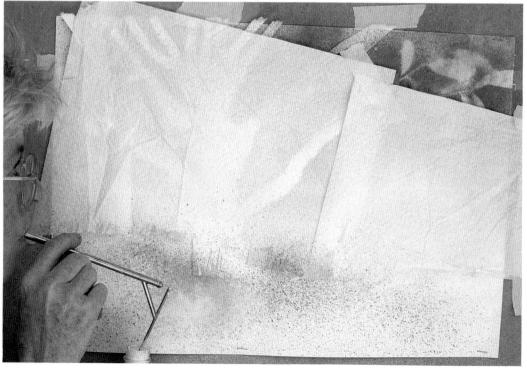

7 **MASK AND SPRAY**
Mask the top portion with paper towel and spray away. First use Olive Green acrylic ink to represent grass. Immediately remask and spray yellow over it. Repeat this on the bottom.

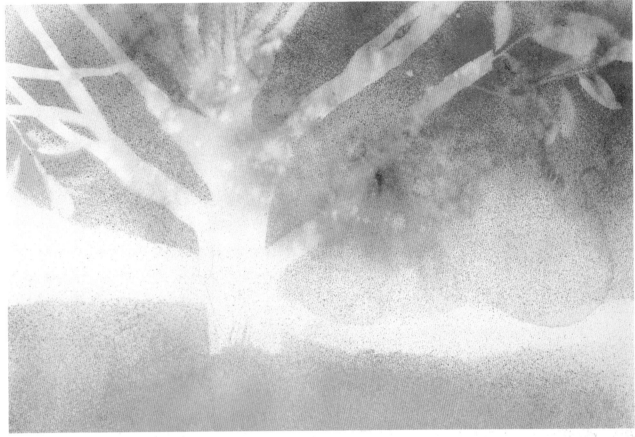

8 OVERALL VIEW
The painting is finished when you cannot better it by adding or subtracting any other elements.

Correcting With Collage

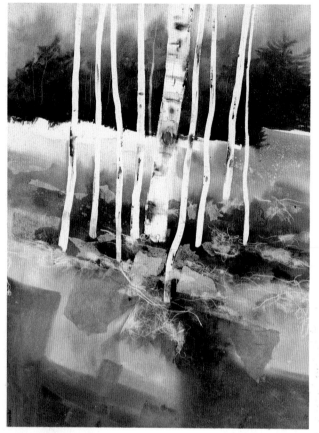

1 COLLAGE FOR CORRECTING
Collage can be used either as an art form in itself or to correct a painting. In this painting the large birch tilts too much to the right and looks awkward. In fact, all the trees slant to the right. To correct this, you can glue and collage paper trees.

2 TRACING PAPER
To plan your corrections, tape tracing paper over the painting. Now draw in the new tree shapes.

3 SARAL TRANSFER PAPER
To transfer your drawing to the paper, place Saral transfer paper between the drawing and your paper. Press lightly to leave a mark.

4 TEAR TREE SHAPES
Place a ruler next to your drawn line and tear slowly towards you. Tearing gives the paper a natural edge that blends easily into the painting when glued. Rives BFK 125-lb. (270gsm) paper is perfect for tearing.

5 GLOSS MEDIUM
Use Liquitex Gloss Medium to glue the trees to the painting surface.

6 BRAYER OR INK ROLLER
Press and roll the paper with a brayer. Make sure the collage piece is firmly attached. Place a piece of paper towel or waxed paper over the tree to keep it clean when you use the brayer.

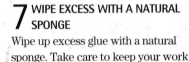

7 WIPE EXCESS WITH A NATURAL SPONGE
Wipe up excess glue with a natural sponge. Take care to keep your work pristine. Take pride in every aspect of your work. You should be your harshest critic.

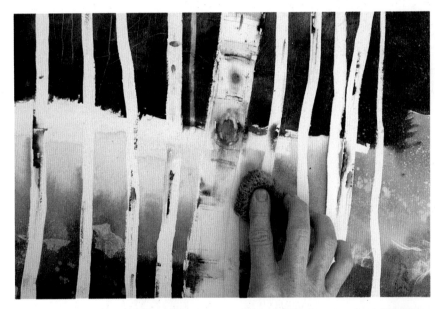

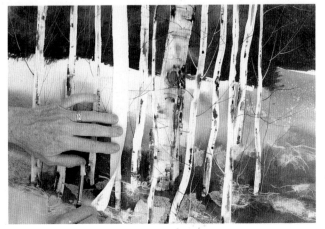

8 GLUE REMAINING TREES AND MODEL TREES
Glue additional upright trees to counterbalance the tilted trees. Make further adjustments and finish rendering branches and trees with a rigger brush or palette knife.

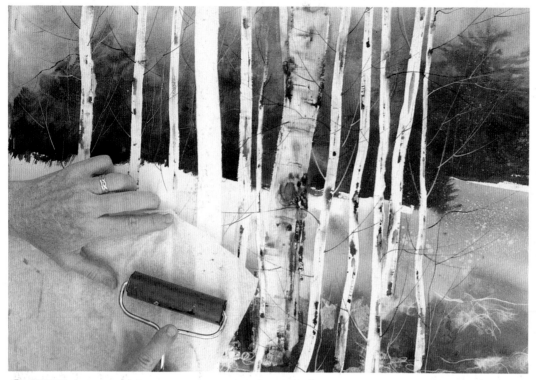

9 BRAYER

Press and roll the trees with a brayer, using paper towels between them to keep the painting clean.

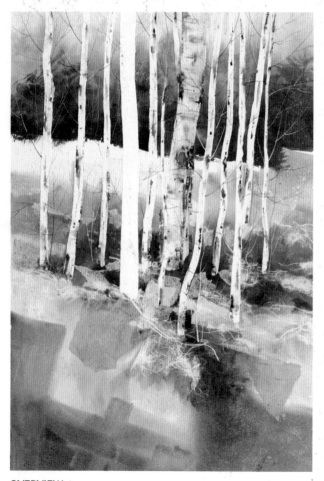

OVERVIEW 1

This painting looks much better now. The balance is better with the second large tree.

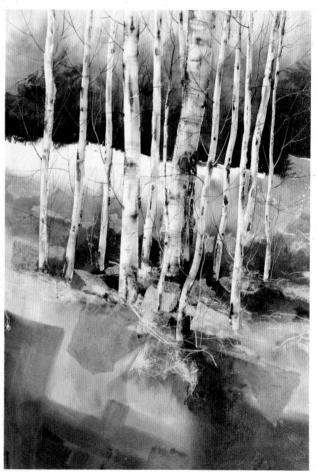

OVERVIEW 2

The trees are all modeled.

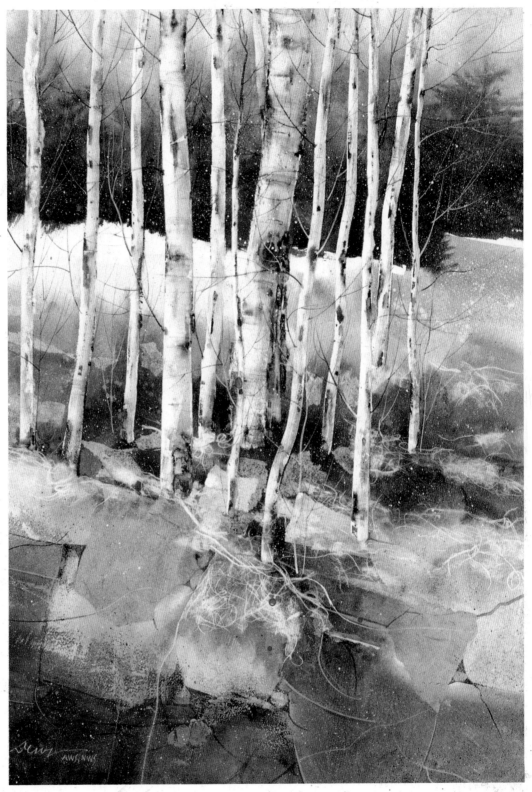

PAT DEWS
Winter Cliff
Watercolor and collage on 140lb. (300gsm) Arches cold-pressed paper
22" × 30" (56cm × 76cm)
Collection of Cynthia Grooms Marvin, Esq.

CHAPTER THREE

Painting Foliage and Grasses

DEMONSTRATION: WATERCOLOR

Realistic Autumn Leaves

DAWN MCLEOD HEIM

PALETTE
 Daniel Smith:
 Permanent Brown
 Quinacridone Gold
 Quinacridone Pink
 Quinacridone Sienna
 Holbein:
 Sap Green
 Winsor & Newton:
 Winsor Blue

BRUSHES
 Nos. 8, 10 or 12 round

OTHER
 A quarter sheet (15" × 11" [38cm × 28cm]) 300-lb. (640gsm) Arches cold-pressed watercolor paper

COLOR KEY
A Sap Green (lt./med.)
B Sap Green + Winsor Blue (med.)
C Quinacridone Gold (lt.)
D Quinacridone Pink + Quinacridone Sienna (lt./med.)
E Quinacridone Gold (lt./med.)
F Quinadricone Pink + Quinacridone Sienna (med./dk.)
G Quinacridone Sienna (med.)
H Permanent Brown (med./dk.)
I Permanent Brown + Sap Green (med./dk.)
J Quinacridone Sienna + Permanent Brown (med./dk.)

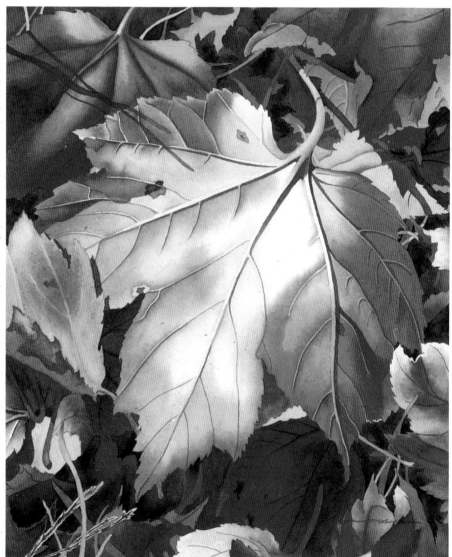

In this project, you will learn how to paint these vibrant autumn leaves, using rich, vivid colors and the charging technique. This is a challenging project. There is ample instruction for the large maple leaf, the dirt and grass. The amount of instruction for the rest of the leaves has been limited. Paint the rest of the leaves on your own by looking at the sample and using the color squares as a guide for which colors to use.

Transfer this drawing onto your watercolor paper, enlarging or reducing as needed.

A B C D E

F G H I J K

1 PAINT THE GRASS AND DIRT, AND UNDERPAINT THE LEAVES

A. *Reinforce the pencil lines.* After you have transferred your drawing, go over all the vein and shadow lines again with your pencil. Do not draw the large leaf.

B. *Paint the grass.* Mix colors A and B. Load your brush with A, and paint all the light green grass, letting each blade of grass dry completely before painting the one next to it. Rinse your brush and blot. Load your brush with B, and paint all the darker-green grass. Let dry.

C. *Paint the large leaf.* Mix colors C and D. Paint the large leaf in sections, using the four large vein lines as dividers. Start with the upper left section. Fully load your brush with C; paint down the stem, then up into the left section as shown. Keep moist. Quickly rinse your brush and blot lightly. Apply the water from your brush along the upper left area. Blot your brush. Fully load your brush with D, and charge D into the water and into C. Paint the pink area, as shown. Continue to paint the rest of that section of the leaf, using alternating charges of C, D and water. Paint the other sections in the same manner as shown in the sample

D. *Paint the other leaves.* Mix colors C, D, E, F and G. Paint the light-value leaves first. Load your brush with D and paint along the upper area of the pink leaf located to the right of the large leaf's stem. Rinse your brush and blot lightly. Using light overlapping brushstrokes, charge the water from your brush into D. Finish painting the leaf with the lighter value of D. Let dry. Paint the rest of the light-value leaves in the same manner, using the charging of water method to create the lightest value on that leaf. Refer to the color squares to help guide you on what colors to use.

When you have finished all the light-value leaves, paint the rest of the leaves by following the sample and using the color squares to help guide you. Start with all the single-colored leaves that have two and three colors charged together. Refer to the color squares to help guide you.

E. *Paint the dirt.* Mix colors B and H. Load your brush with H, and paint a small area, as shown. Take a separate brush that's loaded with B, and charge into H. Paint a short distance, then charge in with H again. Repeat the alternating charging of B and H on all the dirt areas.

Tip CHARGING YOUR WATERCOLORS

By now you have experienced two methods of charging: One is by rinsing and blotting well between colors, and the other is by just blotting (leaving some of the color still in your brush) between colors.

Both of these methods have been used in the leaves on page 47, and both offer great color transition and texture. Practice as often as you need to on separate scrap pieces of 300-lb. (640gsm) paper before starting. Be sure to test on the 300-lb. (640gsm) paper, not 140-lb. (300gsm) paper. The areas you paint on the 140-lb. (300gsm) paper will dry a lot faster than on the 300-lb. (640gsm) paper, preventing you from getting the charging effects you need.

Remember! You do not need to maintain a bead to charge. Just make sure the area you are charging into is wet. Since the values of the colors you will charge together are within the same value range, you should get some really smooth transitions. It's only when one color is a great deal lighter that you may run into problems.

Start these areas with clean
water, then paint.

When you are finished your painting will
look like this.

A B C D E F G H

2 DEEPEN VALUES OF THE LEAVES AND ADD SHADOWS AND NEGATIVE VEINING

A. *Negatively vein the large leaf.* Mix colors C, D, E, F and G. Divide the large leaf into sections as you did in step 1, using your large vein lines as dividers. Further divide the sections between the large vein lines, creating even smaller vein lines. These are the narrow, white ones in the sample.

Paint a section at a time, charging the colors together as shown. Allow each section to dry completely before painting the one next to it. Match the colors shown in the sample to the color squares and to the sample of color-charging at right. A couple of areas have clean water charged in (see sample). Paint the small leaf above the large leaf with C and D.

B. *Paint shadows, and add more color to other leaves.* Mix colors E, F, G, H, I, J and K. Paint the leaves, matching the colors in the sample to those in the colored squares and the colored charging bars, softening some of the edges with water as shown. Let each leaf section dry completely before painting the one next to it. Since there are so many different shapes of charged colors, start on the upper left leaf and paint each leaf shape as you see it. Continue to paint clockwise, as opposed to jumping around the painting. This way, you will have better control over whether or not you have painted the area.

COLORED CHARGING BARS

Although a few of the leaves show only one color, the majority of them have two or more colors charged together. To help you see which two colors they are and how you can identify them with the colors in the sample, use the colored bars showing you how the two colors appear after they have been charged together. Refer to the letter that identifies their color. Let's take, for instance, K/F. Load your brush with K and paint the area on the leaf that the sample indicates. Blot your brush well. Load your brush with F and charge F into K. Finish painting that area with F.

Refer to these bars as often as you need to. Depending on the direction you are painting, the charging can be reversed to read F/K.

Tip PAINTING LEAVES

When painting a leaf that has more than three colors charged together, paint the lightest-colored area on the leaf first, then quickly charge with the darker color. Leaves have lots of texture, so there's plenty of room for brushstroke error. For the leaves that have a very dark value, use lighter brushstrokes so as not to disturb some of the texture and charging done in step 1.

When you are finished, your painting will look like this.

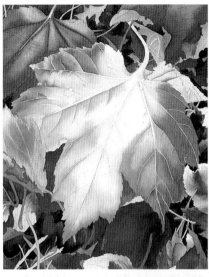

Paint these three areas first. When the sheen is gone, charge along the vein lines with F.

E/J J/F E/J

J/K

K/F

Continue to leave this area the white of the paper.

Wet both of these areas first, then charge in with I.

J/K G K/J

K/L

K/F

J/E

K/H

J/F

F/G

C D E F G H I J K

3 ADD VEIN LINES TO LEAVES AND FINAL SHADOWS TO LEAVES AND GRASS

A. *Paint shadows on grass, and add more color.* Mix colors A and B. Load your brush with A, and paint all the blades of grass that are light green, softening some of the areas with water. Rinse your brush and blot well. Load your brush with B, and paint all the darker-green blades of grass.

B. *Paint shadows and dark spots on large leaves.* Mix colors E, F, J and K. Load your brush with E and, starting at the top, paint down the right side of the leaf's stem. Soften the edge with water. Divide the large leaf into sections again, starting at the upper left again.

Load your brush that has a nice point with E, and paint along the small vein lines, as shown. Rinse your brush and blot well. Load your brush with F, and paint as far as shown. Blot your brush

well. Dip the tip of your brush into E, and finish painting the small vein line.

Continue alternating the colors as you paint the rest of the shadows along the veins.

Paint the larger shadow sections on the left and right sides with F, softening with water, as shown. Some areas are charged with E.

When you are finished with the shadows, load your brush with K, and paint the dark spots on the leaf, blotting the lighter value spots with a tissue.

C. *Paint shadows and veins on the rest of the leaves.* Mix colors A, H, I, J and K. Paint the rest of the shadows and vein lines on the leaves, matching the colors in the sample to those in the color bar and softening some of the edges with water, as shown. Again, to avoid confusion, start at the upper left and paint clockwise.

Tip PAINTING SHADOWS

If you get confused as to which color to use when painting the shadows along the vein lines on the large leaf, maybe this will help: Most of the shadow lines on the leaf are just a darker value of the leaf that has already been painted. In other words, if the section of the leaf is the light gold color, then you would paint the shadow using the darker gold. If the section is an orange color created when you charged the lighter gold into the lighter pink, you would blot your brush that's loaded with the darker gold and place the tip into the darker pink. The darker colors such as H and J occur mainly toward the top, where the four large veins meet.

Soften with water.

Soften along this
edge with water.

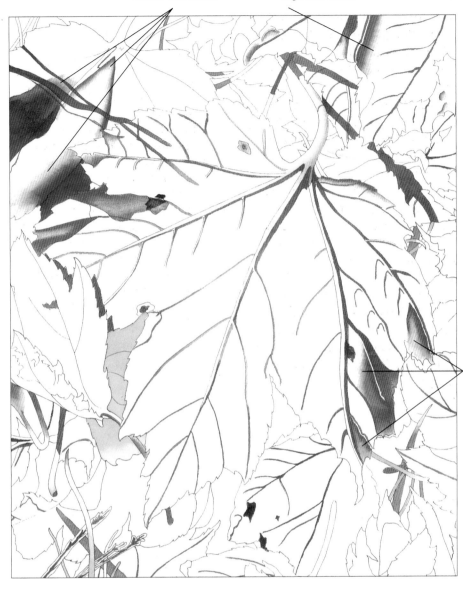

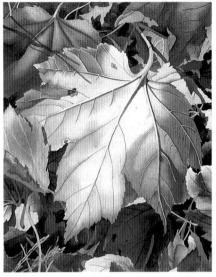

When you are finished with step 3, your
painting will look like this.

Soften with water.

4 FINISHING TOUCHES
Using a clean, moist brush, lightly
tickle some of the surrounding color
over the veins on the right side of the
large leaf. The final piece will look like
the painting on page 52.

DAWN MCLEOD HEIM
Autumn Leaves
*Watercolor on 300-lb.(640gsm) Arches cold-
pressed paper*
12" × 10" (30cm × 25cm)

A	B	E	F	G	H	I	J	K

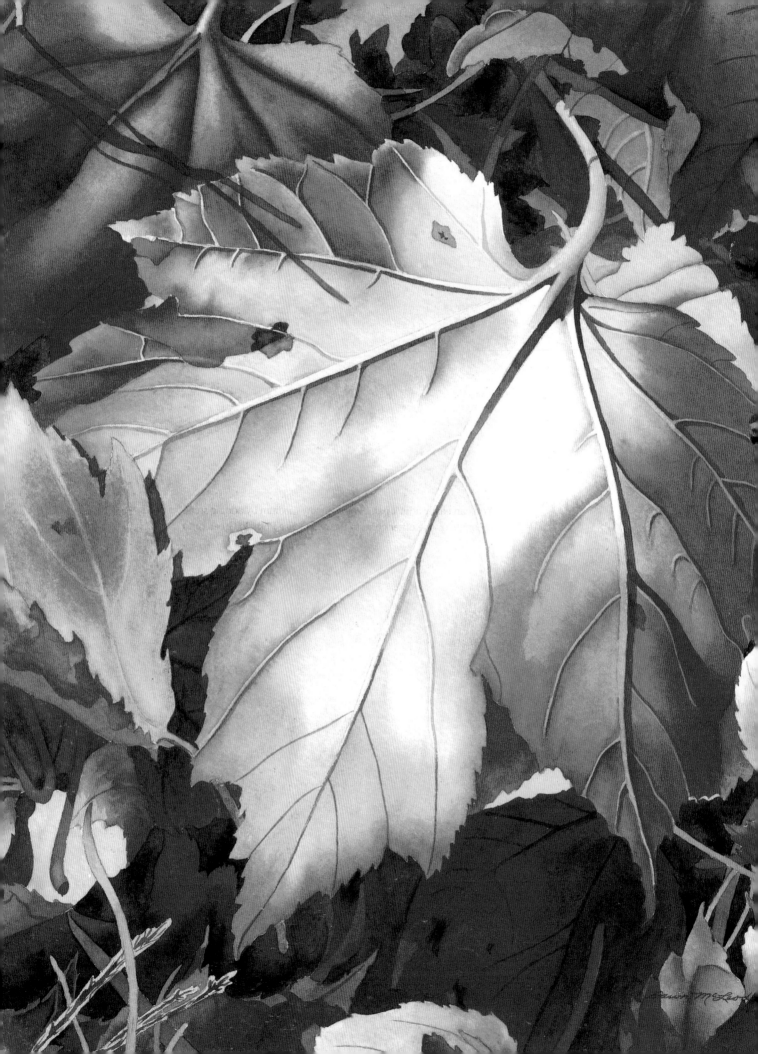

Break Away From Tube Greens

When there are so many ways of mixing beautiful greens, why do some artists depend on ready-made colors? Few manufactured greens are natural looking, and if you have a tube of green you like, chances are you use it too much. An infinite variety of mixtures is possible, as this exercise shows you. The art on this page was created by Nita Leland.

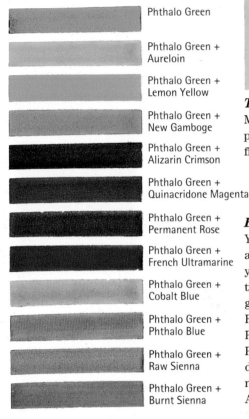

Phthalo Green

Phthalo Green + Aureloin

Phthalo Green + Lemon Yellow

Phthalo Green + New Gamboge

Phthalo Green + Alizarin Crimson

Phthalo Green + Quinacridone Magenta

Phthalo Green + Permanent Rose

Phthalo Green + French Ultramarine

Phthalo Green + Cobalt Blue

Phthalo Green + Phthalo Blue

Phthalo Green + Raw Sienna

Phthalo Green + Burnt Sienna

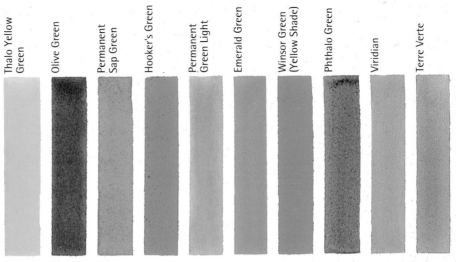

Thalo Yellow Green · Olive Green · Permanent Sap Green · Hooker's Green · Permanent Green Light · Emerald Green · Winsor Green (Yellow Shade) · Phthalo Green · Viridian · Terre Verte

Tube Greens

Many beautiful greens are already mixed and packaged in tubes, like those shown here. The problem is, it's tempting to use them too much and everything begins to look the same. You'll find it's much more fun to make your own greens to fit each situation.

Exercise 1: Getting the Most From Tube Colors

You can easily adjust paint colors in any medium by adding small amounts of one other color to them. Squeeze Phthalo Green onto your palette (or any other color you wish, preferably one with high tinting strength). Mix just enough of a second color with some of the green to change it slightly. Place a swatch of the mixture on a chart. Repeat with every color you have, mixing each with the original Phthalo Green. What a gorgeous array of colors! As powerful as Phthalo Green is, many other colors modify it beautifully, providing delightful new colors to work with. You'll discover exciting mixtures, no matter what color you start with. Try this with Phthalo Blue, Alizarin Crimson, and Lemon Yellow.

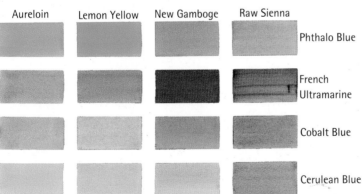

Aureloin · Lemon Yellow · New Gamboge · Raw Sienna

Phthalo Blue

French Ultramarine

Cobalt Blue

Cerulean Blue

Exercise 2: Mix Your Own Green

Yes, blue and yellow do make green—any kind of green you could possibly want. Start with a sectioned sheet as in the illustration shown here. Using Phthalo Blue and Aureloin, mix green and place a swatch at upper left. To the right of this use Phthalo Blue again, but change the yellow to Lemon Yellow. Here's a slightly different green. Continue across the row with your other yellows. Start a new row with a different blue, Ultramarine, and mix this with Aureloin, the same as the yellow above. This results in a slightly duller green than the one you made with Phthalo Blue and Aureloin, but it's still a nice green. However, when you mix New Gamboge and Ultramarine, it's a different story—olive green, for sure. Finish the exercise with the rest of your blues, using the same blue colors across each row and repeating the yellow colors down the columns. You can also do this exercise using an assortment of red and yellow paints to mix orange, or different reds and blues for violet.

Complementary Colors for Foliage

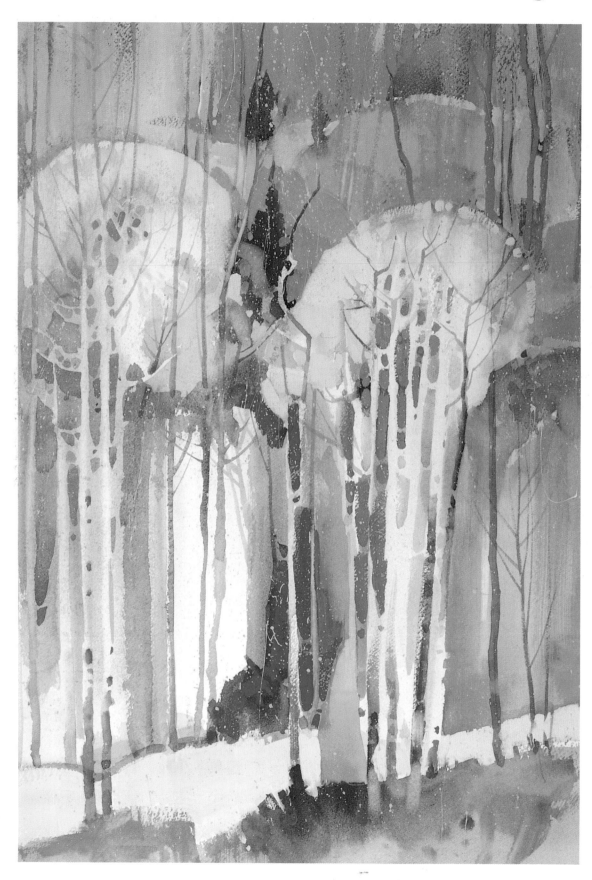

Complementary Color Scheme
Quiller's painting is a good example of an inventive color scheme that strongly suggests a sense of place easily recognizable to anyone who has been to Colorado in the fall. Golden aspen against blue sky, as well as blue and blue-violet complementary shadows, interact beautifully.

ASPEN PATTERNS, GOLD & BLUE
Stephen Quiller
Watercolor and gouache on paper
26" × 18"
(66cm × 46cm)
Private Collection

COMPLEMENTARY TRIADS

Complementary triads are easy to find, fun to use and their contrasts are exciting. Just select any two direct complements and add one of the two colors halfway between them. For example, you may select red-orange and blue-green tertiary complements; the third color could be either yellow or violet. Each adds a distinctive spark to the original pair of complements and gives a totally different color accent.

Modified triads are made up of three colors, skipping over one color between each of the three on a twelve color wheel. They are nearly analogous, making for harmonious mixtures. But at each end of the three-color arc they make up, there are two colors that come close to being complementary, providing slightly more contrast than analogous colors. There are twelve unique modified triads.

Modified Triad Colors

Nita Leland's color scheme is a modified triad of yellow, green and blue with yellow dominating. She used Cerulean Blue and Phthalo Blue so she would have a light blue for the sky and a darker blue to mix the dark green background trees. Burnt Sienna was used to mix low-intensity dark yellows and the chromatic neutrals in the shadows.

NITA LELAND
Colorado Gold
Watercolor on paper
24" × 18"
(61cm × 46cm)

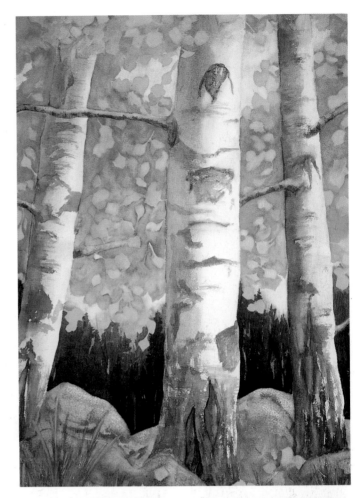

Exercise: Exploring Complementary and Modified Triads

Mingle the colors of the complementary triads, then the modified triads. Can you see the striking differences between the two types of color schemes? Which do you prefer, the powerful contrasts or the more gentle harmonies? What subjects would work with each combination of colors? Make samples and sketches with the ones you like best.

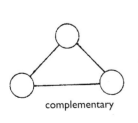

complementary

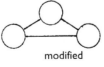

modified

Red-orange, blue-green, yellow

Magenta, green, blue-violet

Magenta, violet, cyan

Magenta, orange, yellow

Try Bold Bright Foliage Colors

BLEND MIXTURES AND TUBE COLORS

A colorful blend of green mixtures and tube greens creates a lively surface throughout this picture, an excellent example of how to use greens effectively. Don't be afraid to use greens. They are troublesome only when you mix warm yellow with warm blue, or if you use the same boring green everywhere.

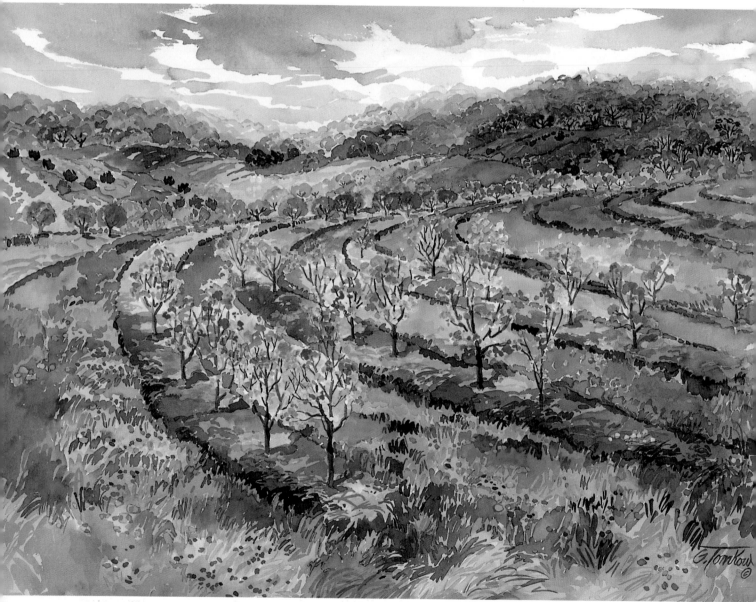

GWEN TOMKOW
Orchard in Round
Watercolor on paper
20" × 28" (51cm × 71cm)
Collection of the artist

DON'T LIMIT FOLIAGE TO GREEN

Schmidt's strong, colorful paintings are constructed using compatible colors that are well matched for intensity and tinting strength. Because she works in acrylics, her paints are more opaque and seem brighter than watercolors; the brightness is partly because of the final finish of acrylic medium and varnish she applies.

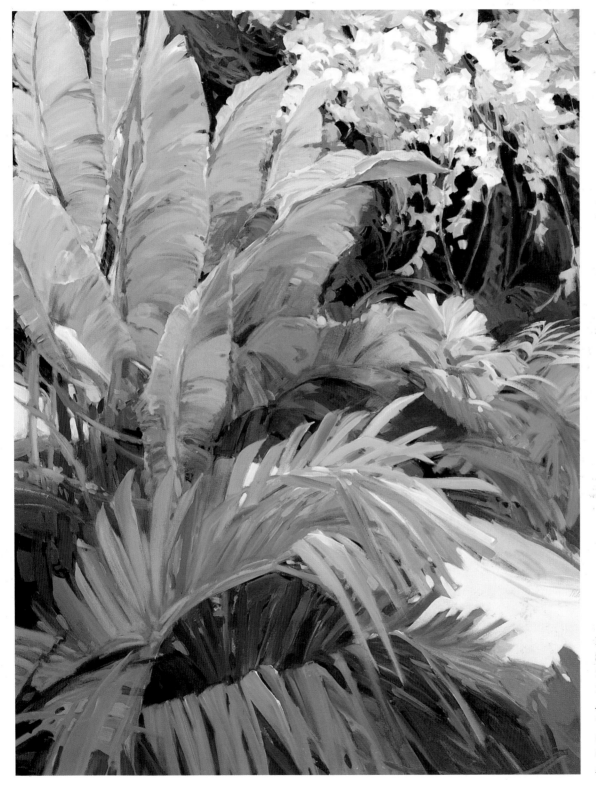

MARY JANE
SCHMIDT
Tropical Series 125—
Tropic Leaves
Acrylic on canvas
72" × 60"
(183cm × 152cm)
Courtesy of Rice and
Falkenberg Gallery

Leaf Textures in Pen and Ink

CLAUDIA NICE

Leaves are as varied in size, shape and texture as the flowers they feed. Different pen strokes are useful in their portrait, as well as numerous watercolor techniques. Here are some leaf examples for you to try.

Pen-and-ink contour line

Mixed-Medium Rose Leaf

1 Begin with a pencil sketch and a light watercolor wash of Phthalo Yellow Green and Chromium Oxide Green.

Paint a light blue-green sheen area.

Blotted area

2 Lightly outline the veins with pen work and cross-hatch the areas between. Use Payne's Gray liquid acrylic for an additional highlight.

3 Drybrush a second wash of Hooker's Green Deep and Payne's Gray, leaving some of the previous paint layer to show through. Add as much dry-brush shade work as desired.

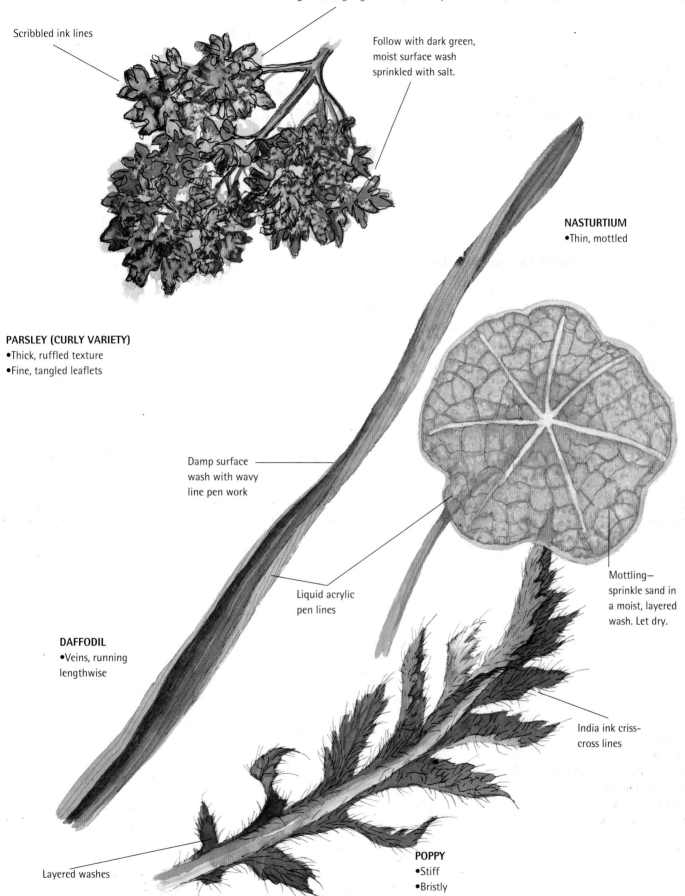

Scribbled ink lines

Begin with light green wash. Let dry.

Follow with dark green, moist surface wash sprinkled with salt.

NASTURTIUM
•Thin, mottled

PARSLEY (CURLY VARIETY)
•Thick, ruffled texture
•Fine, tangled leaflets

Damp surface wash with wavy line pen work

Liquid acrylic pen lines

Mottling— sprinkle sand in a moist, layered wash. Let dry.

DAFFODIL
•Veins, running lengthwise

India ink criss-cross lines

Layered washes

POPPY
•Stiff
•Bristly

Weeds and Grasses

The earthy colors and varied textures of grasses and weeds combine to make them exceptional close-up studies. The artwork on pages 60–65 was created by Claudia Nice.

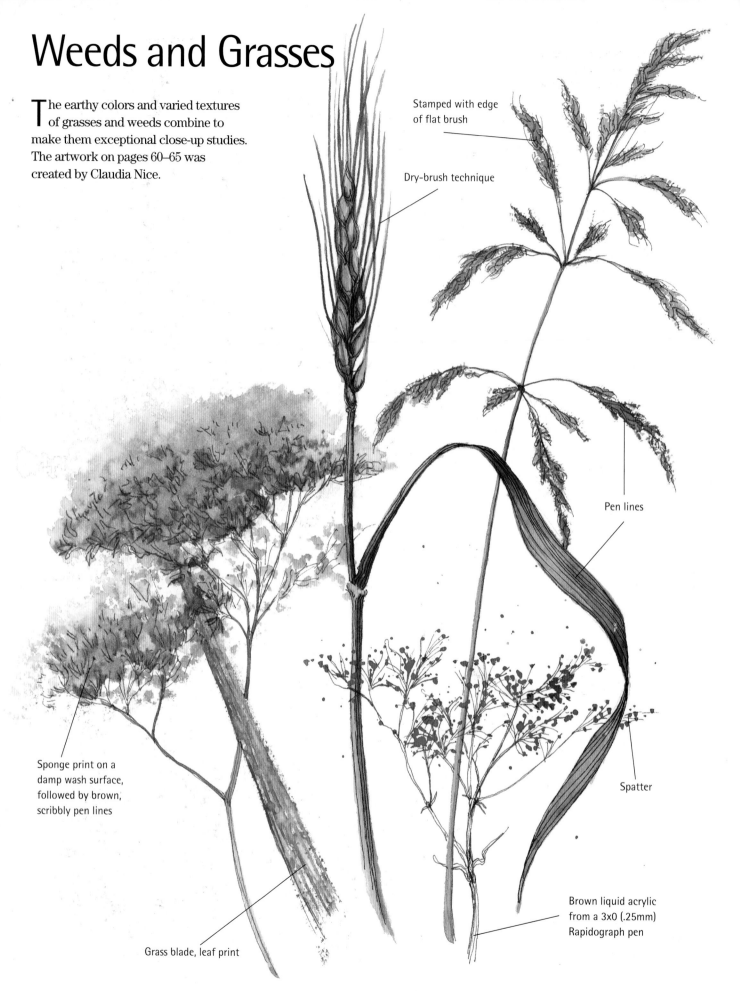

Stamped with edge of flat brush

Dry-brush technique

Pen lines

Spatter

Sponge print on a damp wash surface, followed by brown, scribbly pen lines

Grass blade, leaf print

Brown liquid acrylic from a 3x0 (.25mm) Rapidograph pen

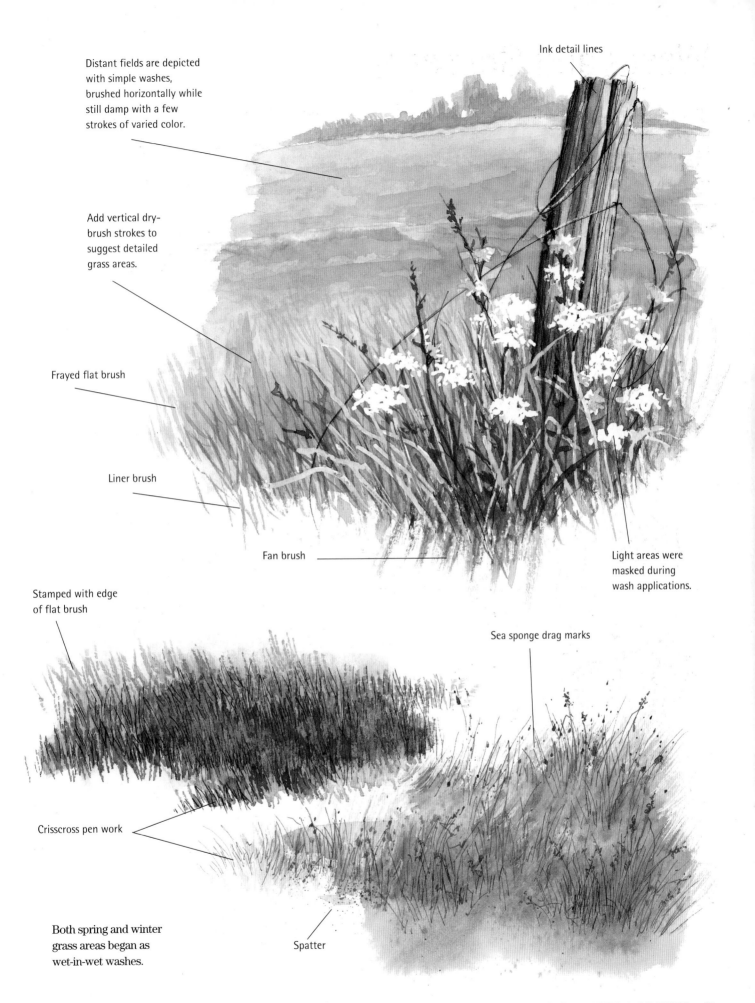

Distant fields are depicted with simple washes, brushed horizontally while still damp with a few strokes of varied color.

Ink detail lines

Add vertical dry-brush strokes to suggest detailed grass areas.

Frayed flat brush

Liner brush

Fan brush

Light areas were masked during wash applications.

Stamped with edge of flat brush

Sea sponge drag marks

Crisscross pen work

Both spring and winter grass areas began as wet-in-wet washes.

Spatter

Moss and Ferns

Both moss and ferns have a delicate appearance and a rich green coloration that almost seems to glow. However, their textures differ greatly. Mosses are usually thick, fluffy mats, while most ferns are thin-leafed, lacy plants.

FRAGILE FERN

1 Scribble a pen-and-ink sketch.

2 Tint with Sap Green wash.

3 While still damp, lay in additional earthy greens and browns.

4 Deepen the shadows with more scribbly ink lines.

POLYPODY FERN

These two ferns are prints from actual leaves that were brushed with watercolor and pressed on damp paper.

This print was further enhanced with watercolor washes and dry-brush detailing.

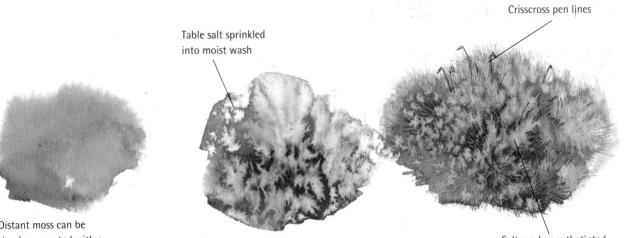

Table salt sprinkled
into moist wash

Crisscross pen lines

Distant moss can be
simply suggested with a
variegated damp surface
or wet-in-wet wash.

—or bring the moss into the
foreground focus by adding
texture and details.

Salt marks gently tinted
with a Sap Green wash

Pen-and-ink stippling

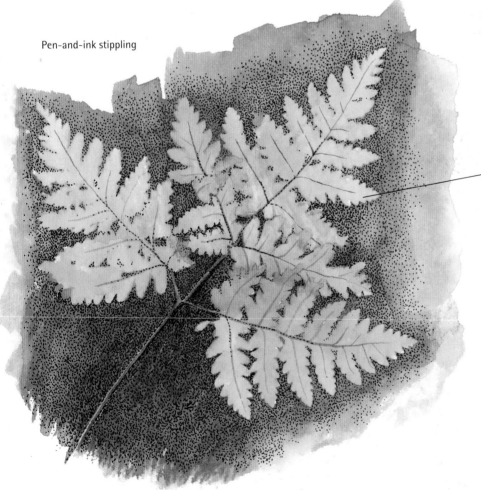

Background wash was brushed over a
flattened fern frond laid against the
paper, creating a negative print.

Negative leaf print was
tinted with a watercolor
wash and detailed with
dry-brush work.

OAK FERN

Lichen

Appearing in many forms and earthy hues, lichen is a natural excuse to add a bit of color or bold texture to a rock or aged piece of wood.

1 Begin by masking out the ruffled lichen shape and adding a simple wash.

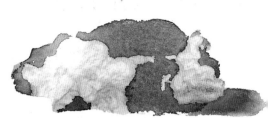

Or lay in the wet surface wash first and draw the lichen shape with alcohol.

PIXIE CUPS

SHIELD LICHEN

2 Detail the lichen patches with additional washes, dry-brush work and Rapidograph scribble lines.

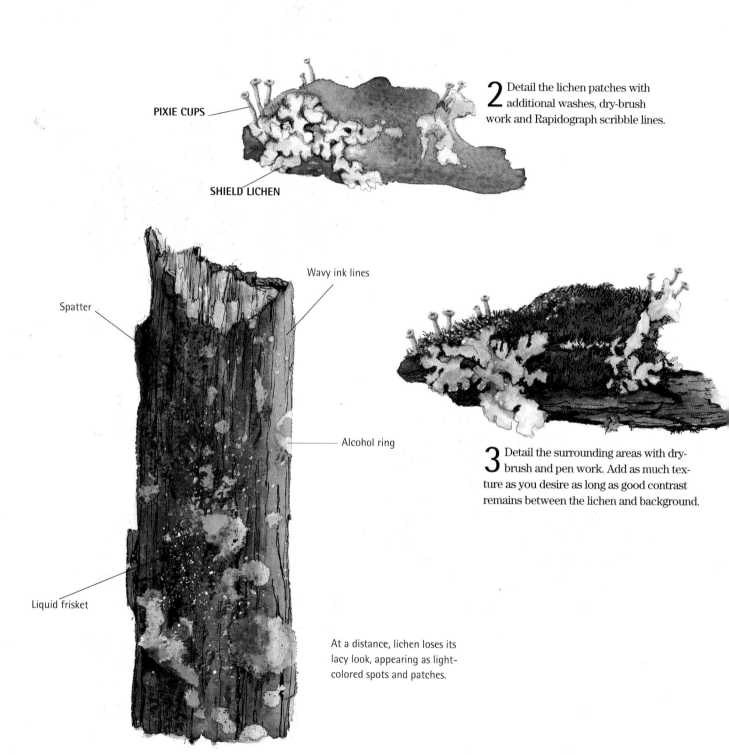

Spatter

Wavy ink lines

Alcohol ring

Liquid frisket

At a distance, lichen loses its lacy look, appearing as light-colored spots and patches.

3 Detail the surrounding areas with dry-brush and pen work. Add as much texture as you desire as long as good contrast remains between the lichen and background.

Mushrooms

The typical mushroom texture is smooth and rounded, with a matte to glossy sheen. Many have a translucent glow.

The mushrooms sketched here are a combination of brown liquid acrylic pen work, layered washes and dry-brush detailing.

MEADOW MUSHROOMS

Wavy lines

Contour lines

White patches were masked while the basic wash layers were applied.

White paper sheen marks

FLY AGARIC MUSHROOMS

Dry-brush and pen detail work

VARIEGATED MILKY MUSHROOMS

YELLOW MOREL MUSHROOMS

Morel fold crevices were created with plastic wrap pressed into varied, moist washes and left to dry. Details were added using drybrush techniques and pen.

Paint Grasses and Reeds

DONALD W. PATTERSON

The strong overhead light after a shower makes colors more intense and makes details stand out distinctly. This is especially true when these saturated colors are set against a backdrop of lingering dark clouds.

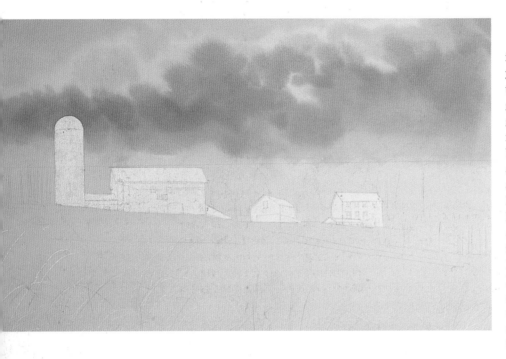

1 PAINT THE LIGHT

After you have prepared your paper (see instructions on page 69) and have completed your basic drawing, apply masking fluid to the buildings, cornfield and foreground grasses. Use a ruling pen (a traditional graphic design tool) to outline buildings with masking fluid, and then fill them in with a brush. To paint the light, apply four glazes at 5 percent color intensity over the entire area in this order: Yellow Ochre, Prussian Blue, Alizarin Crimson and Cadmium Lemon. Make sure the glazes dry between applications. Mix three light washes for the sky: Prussian Blue; Prussian Blue and Payne's Gray; and a denser wash of Prussian Blue and Payne's Gray. Wet the entire sky area until your paper is very damp but not dripping. With your board slightly tilted toward you, use a no. 12 round sable to brush on sky colors in the order the washes appear above. Have fun—wet-in-wet is not a precise science.

2 THE TREES

Use brushes and natural sponges to dab on the fall foliage. Use the following palette: Hooker's Green Dark, Olive Green, Sap Green, Alizarin Crimson, Raw Sienna, Yellow Ochre and Payne's Gray.

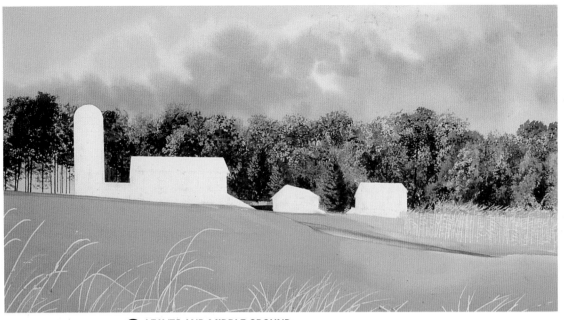

3 LEAVES AND MIDDLE GROUND

To paint leaves highlighted by the sun, use Winsor & Newton gouache colors: Cadmium Yellow Pale, Flame Red, Cadmium Orange, Yellow Ochre, Permanent Green Light and Zinc White. For this kind of highlighting use older nos. 3 and 4 round sables that no longer come to a fine point. They help produce an uneven, textured effect. When the trees are complete, remove the masking fluid from the buildings with a rubber cement pickup. Paint the field over the masked foreground grasses using a wash of Sap Green, Hooker's Green Dark and Yellow Ochre. Paint the driveway with Payne's Gray and Yellow Ochre; paint the cornfield with Yellow Ochre.

Tip CORRECT A MASKING FLUID ERROR

If you have incorrectly masked an area of your painting, remove the mask and paint over the area, matching the colors in your painting and adding textural detail at the same time. Then go back in and repaint the area correctly.

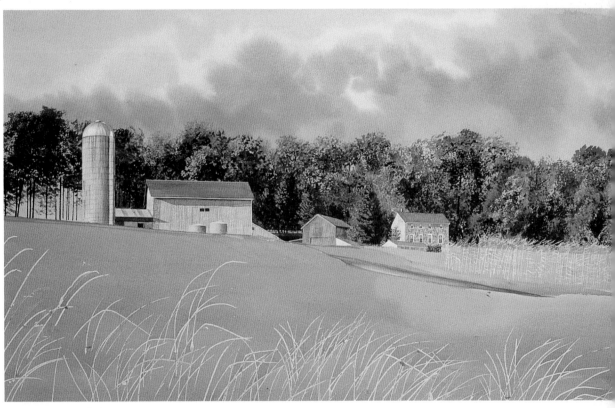

4 PAINT THE BUILDINGS

Lay color on the buildings in stages, starting with transparent colors: Yellow Ochre, Burnt Sienna, Payne's Gray, Prussian Blue and Winsor Green. Continue to fill in the buildings, and begin to add details (window mullions, etc.) with gouache. Add masking fluid to the foreground grasses and corn for additional texture.

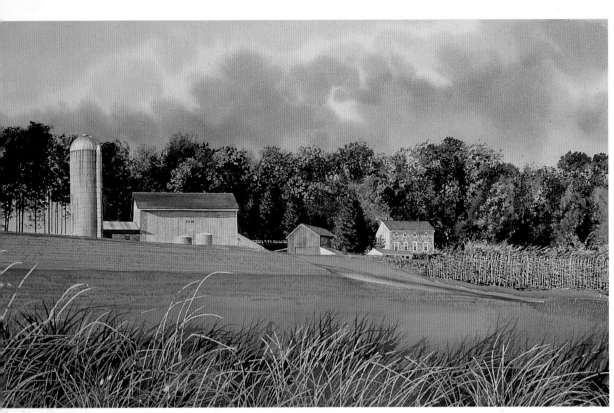

5 DARKEN THE NEGATIVE AREAS IN THE GRASSES

Deepen the colors on the field and cornfield. Use a dry-brush technique to add texture to the field. Make a final application of masking fluid to the grasses and corn (see the demonstration on grasses on page 70). Brush a very dark wash of Sepia and Payne's Gray over the corn. Brush darker greens over the grasses.

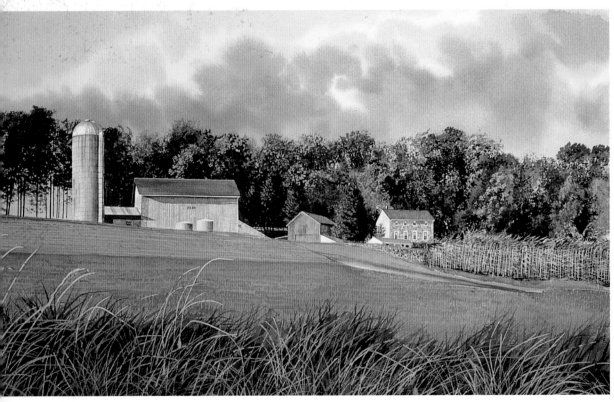

6 REMOVE THE MASKING FLUID

Remove all of the masking fluid and wash a light color all over the areas of grass and corn. Use a soft no. 12 sable or equivalent to avoid disturbing the dark colors in the negative areas.

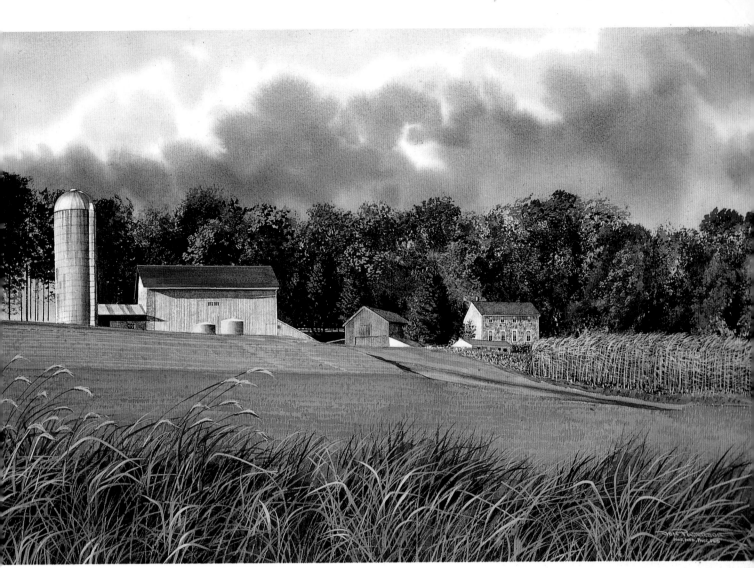

7 FINAL TOUCHES

Using gouache, paint in the blades of grass highlighted by the sun, and then highlight some leaves and stalks of corn. Notice the unified lighting of the finished work. Step 1 helps hold the sky and the ground together to create this distinct mood.

DONALD W. PATTERSON

Passing Shower
Watercolor on 300-lb. (640gsm) Arches cold-pressed paper
17" × 27" (43cm × 69cm)

Tip PAPER PREPARATION
Staple a full sheet of 300-lb. (640gsm) Arches cold-pressed paper to a piece board using a staple gun and ¼" (6mm) staples approximately 3" (80mm) apart. The paper will be very easy to lift off upon completion of the painting. Next, make a careful graphite drawing of the painting with a moderately hard pencil. Draw borders. Tape these four sides with 1" (25mm) drafting tape. Use drafting or masking tape for its low-tack property: It will not damage the paper's surface when removed. Taping provides a clean white border after removal—an instant mat.

Close-Up: Grasses and Reeds

DONALD W. PATTERSON

Reeds and grasses interact exquisitely with sunlight. The intricate pattern of fine lines—some glowing with light, some in shadow—is an important element in a composition, especially in the foreground, as seen in *Passing Shower* on page 69. Painting this pattern in transparent watercolor is challenging.

Painting thousands of negative areas created by the many layers of criss-crossing stalks is a daunting task. The technique demonstrated here was discovered through experimentation with liquid masking fluid. Layers of fine-lined masking fluid are alternated with layers of increasingly dark washes. When you

try this technique, purchase the finest ruling pen you can afford. A student-quality pen does not work very well. The pen should lay down a controlled, heavy coating of fluid with an easily adjustable line weight.

1 THE DRAWING

Very quickly draw the direction patterns of the stalks with a graphite pencil. Do not attempt to pencil in every stalk. Use a ruling pen to apply masking fluid to the stalks you want to remain the lightest.

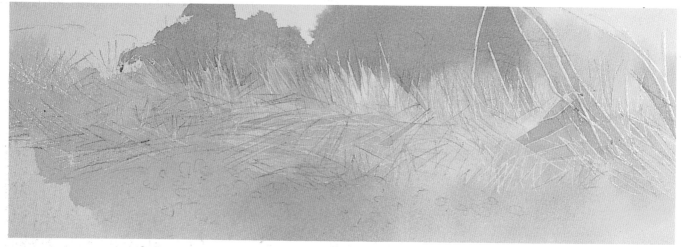

2 ALTERNATE COLOR AND MASKING FLUID

When the masking fluid is dry, apply a wash of light colors over the entire area. Use a soft brush large enough to do this quickly. When the wash is completely dry, stroke on masking fluid for the second layer of darker stalks.

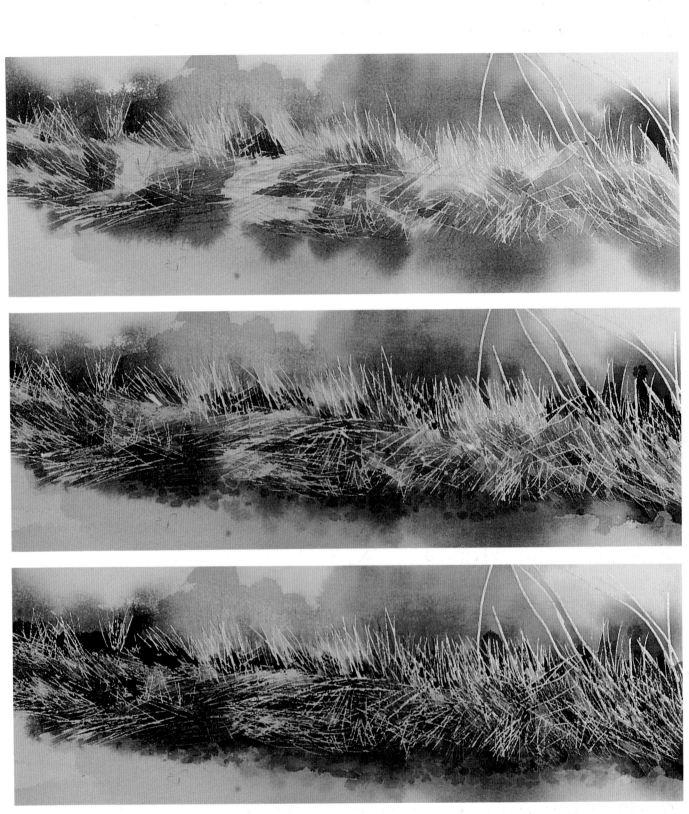

3 CONTINUE LAYERING

Repeat the process, using darker washes each time, until only the darkest negative areas are not coated with masking fluid (top and middle). Wash over these negative areas with your darkest color (bottom).

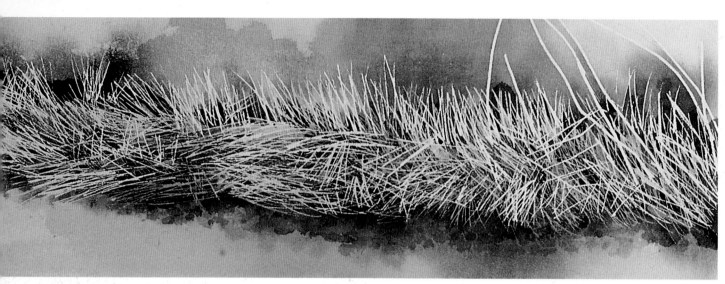

4 REMOVE THE MASKING FLUID

When the masking fluid is completely dry, remove all of it with a kneaded eraser. To make sure you removed it completely, gently rub across the painting surface with clean, dry hands. You will easily feel any remaining mask.

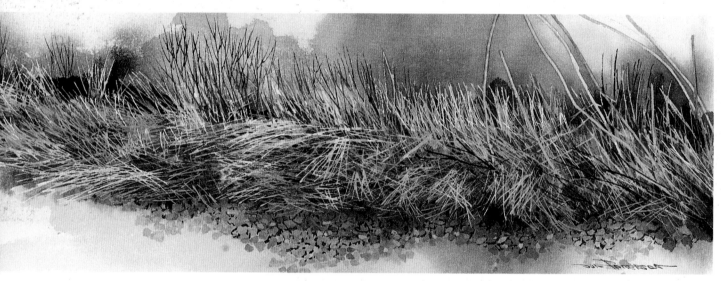

5 FINAL TOUCHES

You can now wash a light color (or colors) over the white stalks left by your first application of masking fluid (step 1). Paint on a darker value and then blot it with a paper towel to get the correct, lighter value. The blotting blends in any overlapped color on the previously painted areas. Create form and depth within the masses of stalks by brushing in shadow areas with either a dry or wet surface, depending on the effect you desire. Finally, use gouache to highlight certain stalks where necessary. You may need to darken selected negative areas for extra punch. In this painting, dark reeds were added across the back and on the right side.

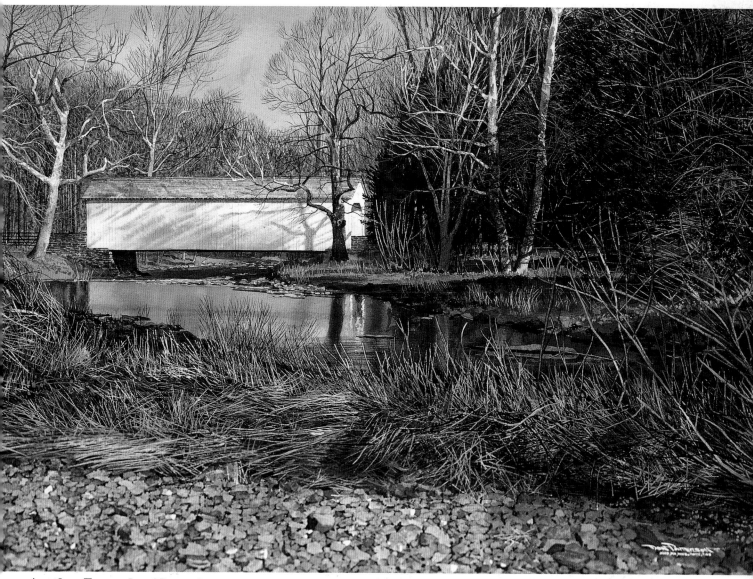

Another Example of Layering

The most prevalent technique used in *Cabin Run* is the one demonstrated in "Close-Up: Grasses and Reeds" on pages 70–72. The texture created by the countless branches and reeds makes this scene compelling. It seems paradoxical that the small rocks in the foreground required a technique more painstaking than the technique used for the branches. The rocks were painted carefully, one at a time; the darker negative areas were filled in last.

DONALD W. PATTERSON
Cabin Run
Watercolor on 300-lb. (640gsm) Arches cold-pressed paper
18" × 26" (46cm × 66cm)

Winter Works Magic on Trees and Foliage

Drawing Trees in Light Snow

The artwork on pages 74–81 was created by Stanley Maltzman.

Drawing A

A 2B graphite pencil was used to capture the light dusting of snow that outlines the tree trunk and limb in this drawing. A light pencil line indicates the upper edge of the snow. The shading of the trunk and limbs was done with a 6B graphite pencil worked up to the snow line. A few darks were added under the snow to indicate thickness and add to the impression that the snow is lying on top of the bark. To intensify the feeling of light snow, a small amount of snow was left at the crotch of the fore-shortened limb for balance and interest. This sketch was drawn on Rives BFK, which has very little tooth to the surface.

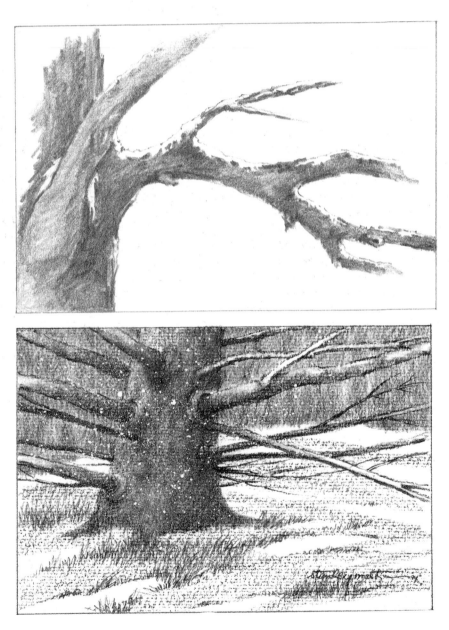

Drawing B

This drawing was worked on a piece of Arches Ingres paper, a laid paper that was specifically chosen for its textured surface. A 4B charcoal pencil with a flattened lead was dragged across the surface of the paper to give the appearance of light snow covering the ground. Showing some grass and spots of snow-covered ground creates an interesting pattern. The dark, wooded background is kept simple so as not to distract. The snowflakes were induced with a bristle brush and white gouache water-based paint. Be careful not to overdo this process. A few spatters tell the story.

Techniques for Showing Heavy Snow

Drawing C

This is the same tree as in drawing A but with a heavy snow. A 2B graphite pencil was used to sketch in the trunk and limbs, but this time more white space was left to indicate the heavier snow. Notice that snow was included on the trunk of the tree. When you have a heavy snow, blowing wind produces this kind of buildup. The dark shading was done with a 6B graphite pencil.

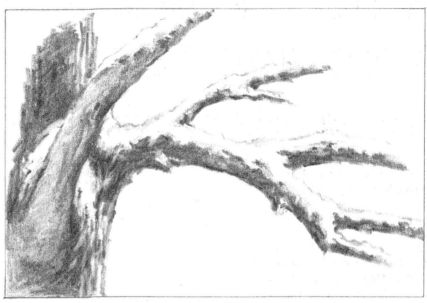

Drawing D

The basic composition of this drawing is the same as drawing B, only with a heavy snow instead of a light snow. The background, which was darker before, is now lighter to show that the woods have been sprinkled with white snow. The limbs have more snow on them, and their undersides are a little lighter in value to show reflected light from the snow. Notice the buildup of snow on the bark and at the base of the old pine. The trunk was made darker for design impact and to show that it is wet and darker when you have heavy snow. The lines in front of the tree complete the drawing. Rives BFK paper and 2B and 4B charcoal pencils were used.

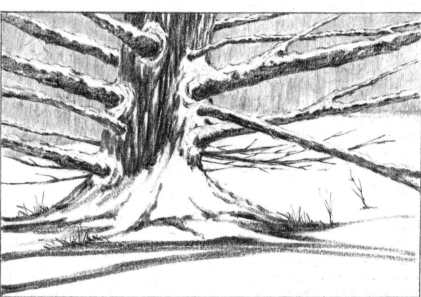

Drawing a Snowy Landscape

STANLEY MALTZMAN

Preliminary Sketch

Preliminary studies help put your thoughts down on paper, so you can develop a satisfactory composition before starting to work on your finished drawing. This sketch was done on a piece of vellum layout paper using a 2B and a 4B charcoal pencil and a piece of soft vine charcoal for drawing tools. A piece of white pastel was used to create as much snow as needed.

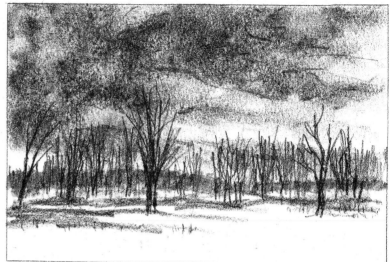

1 Create a rough sketch to use as a rough guide in the placement of elements in the drawing. There's no sense putting in the foreground trees until the sky is finished, as they would only disappear as you model the clouds.

2 Sketch the clouds in with a piece of soft vine charcoal. Then blend with a stomp until you have the suggestion of clouds as shown. Spray this very lightly with workable fixative. When dry, use a carbon-based pencil, to emphasize the cloud shapes. The fresh, black pencil applied on top of the stomped charcoal base makes an interesting texture. At this stage, the patterns of the snow and land are indicated.

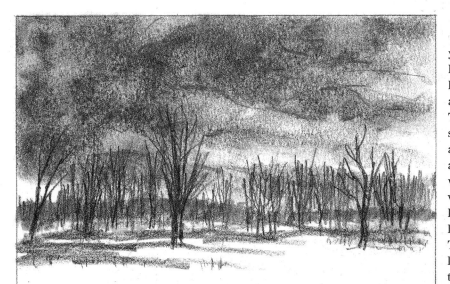

3 Begin building up the land shapes. Every so often, with a fine point on your pencil, make some small vertical lines where the land meets the snow. The lines should be irregular, of different sizes and go past the land shape into the snow. This gives the appearance of weeds or shrubs sticking up through the snow. Use a B pencil to work the background trees and parts of the landscape, alternating with a 2B or a 4B pencil to acquire the values you need. Work the background lighter before adding foreground trees and land shapes. This way, you layer elements. The darks in the foreground cover the lighter background values, which gives the picture perspective.

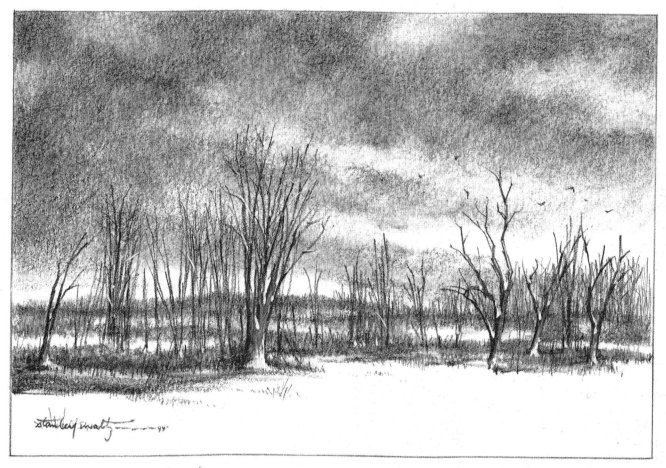

4 Notice the changes that occurred from the preliminary sketch to this finished drawing. The sky is basically the same except for the addition of some frolicking crows. The landscape was changed to include more snow between the land shapes, and some snow was added to the trees with white gouache. Basically, the positioning of the trees is fairly close to the original concept.

A word of caution: When placing flying birds in your landscape, do not overdo. Incorporate them with the overall design so they don't look like an afterthought.

Drawing Tree-Covered Mountains

Snow-covered mountains present a variety of shapes and patterns to compose beautiful winter landscapes. This sketch was done on a piece of vellum layout paper using a 2B and a 4B charcoal pencil and a piece of soft vine charcoal for drawing tools.

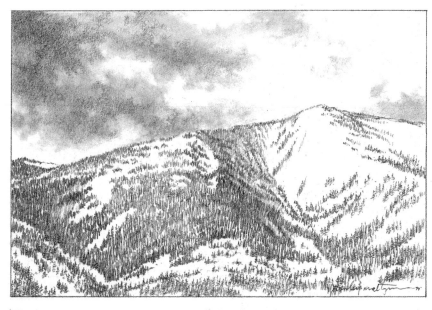

Tree Silhouettes

The skyline has silhouetted against the sky a line of trees that resembles the stubble of a beard. Mountain ridges with trees offer many opportunities for creating interesting shapes and designs, but be careful not to make ridges parallel to each other or make trees all alike. Vary your angles and shapes to create interest.

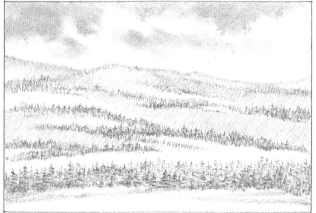

Snow-Covered Trees

This mountain range from Yellowstone National Park is different from the Catskill Mountains. It has these beautiful snow-covered peaks with thousands and thousands of trees breaking through the snow. Notice how the tree shapes were used to create designs across the mountain range.

The trees were indicated with short lines at the peaks and upper parts of the mountains. The tree lengths were varied throughout the picture. A few identifiable pine shapes are spotted throughout, creating the illusion of a mountain range covered with snow and pines.

Varying Values

The tree line on the left is gradually lightened as it moves to the right. As you move to the foreground, shapes get larger and darker, creating a sense of depth and perspective. It is not necessary to include every limb of the trees; the vertical lines spotted around give the appearance of many trees on a snow-covered mountain.

Snow on Trees

The way you portray snow on trees will tell the viewer if it was a heavy snow, a driving storm or just flurries. A driving storm would show more snow covering the trunk and vertical wood of a tree; a light snow would show much less.

You can also tell a story with your winter sky. In the drawing below, you see a pine tree in a field after a snowstorm. The gray sky, with a little white showing, indicates that the storm is over and the sky might be clearing. This drawing captures the mood created when the sky and the land take on a warm gray appearance after a storm. Except for the large pine, all the elements have a soft look accompanied by the kind of quiet found in fields and woods.

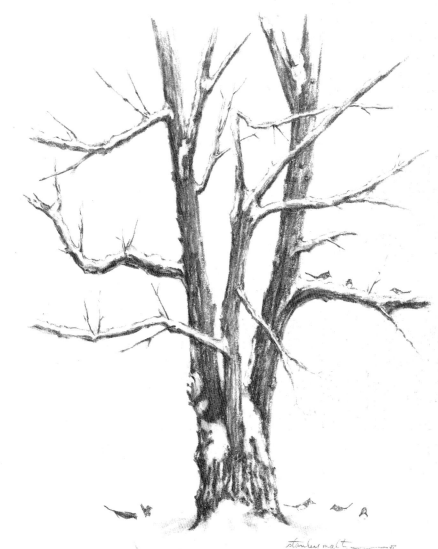

Locust Trees

This locust tree was sketched with an aqua-media pencil. Then parts of the tree were dampened with a wet brush, blending the pencil marks into soft gray tones. When the paper dried, pencil was again used on the drawing to accent the darks and add more character to the wood. The paper was 100 percent rag, four-ply museum board.

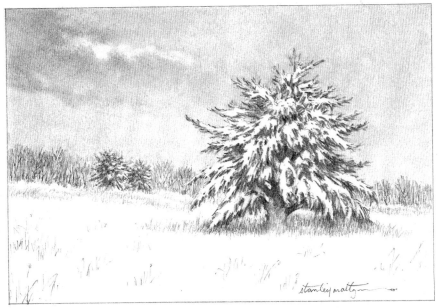

Evergreens

To portray a pine tree covered with heavy snow, find the pattern created by the snow on the limbs and the dark spaces between them. The snow is the white of the paper, and a B graphite pencil was used for the darks of the tree. Notice the spaces between the trees in the background woods, giving the feel of a heavy snow. An HB pencil was used for the background woods, as well as the weeds under the tree and sticking out of the snow.

Drawing Winter Leaves

The next time you take a walk after a snowfall, notice the leaves lying in the snow—some partially buried, others lying on top in various shapes and positions, such as an oak leaf curled up like a beckoning hand. But how do you get a pile of snow into the studio and keep it from melting? You could take photographs, but if you want to be more intimate with your subject than photography allows, here is a solution.

First, collect a large variety of leaves. Use a large paper bag so the leaves will not be crushed. Two dozen leaves will give you enough choices for your composition. You'll also need a small box of white soap powder (make sure it is a powder, not flakes) and a 14" × 17" (36cm × 43cm) piece of heavy illustration board. Pour some soap powder on the board, keeping some in reserve. Then with a small brush, shape your "snow." Make little hills and valleys, keeping it irregular like snow would be in a wooded area.

Arrange your composition one leaf at a time. Use a spoon, spatula or wide brush to push the snow around. Create the impression that your leaves are part of the forest floor or a snow-covered field. When your leaves are arranged, take a spoonful of powder, and holding it about six inches away, gently tap the spoon to create your own snowfall. You might also try dropping some leaves on top of the snow. They might land just where you want them.

STANLEY MALTZMAN
Winter Leaves
Wolff pencil on Whatman
paper
18" × 22" (46cm × 56cm)
Collection of Brenda Shears

Brush white soap powder into little hills and valleys to form natural looking snow.

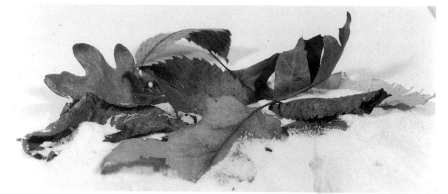

Arrange your leaves into a pleasing composition, then sprinkle a little powder over them for a snowfall effect.

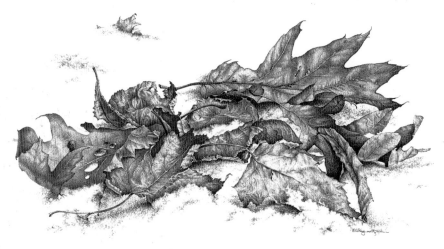

To start your drawing, you can begin either on a good sheet of paper or on a piece of tracing paper. If you choose the latter, you can then transfer the contour sketch to your working sheet and start shading. The beauty of using tracing paper is that when you want to make changes, you can lay a clean sheet of tracing paper over what you have and redo the sections you wish to change.

Once you've transferred the sketch to your working sheet, lightly add the main lines to the leaf. You do not have to include every line, just the center line with the larger offshoots. The rest you will simulate with your rendering. Pick out the lightest leaf, and with an H or HB graphite pencil, put in an overall tone to the leaf. Come back again with the same pencil, adding ripples and veins. With the next degree of graphite, add more definition and darks. You can lift tone with your kneaded eraser.

After you finish one leaf, use the circular method (see page 12) to put a light tone on all leaves to guide you as you add additional tones to make one leaf darker, one leaf recede and another come forward. Add a few holes or mold marks, but keep it simple; you just want to give the leaves a touch of reality.

Make the snow with light circular and wiggly lines, adding the dark shadows last.

Remember to work your darks against lights and lights against darks. Use a sharp point to get more control of the marks you put on the paper, and keep a sheet of paper under your hand to prevent smearing as you work.

You can work out your contour drawing on tracing paper, then transfer it to your good drawing paper when you're satisfied with it. These leaves were drawn extra dark to emphasize the line. Normally the lines are kept light and show the various tones which hold the edge. Keep your preliminary sketch light to avoid that hard-outline look.

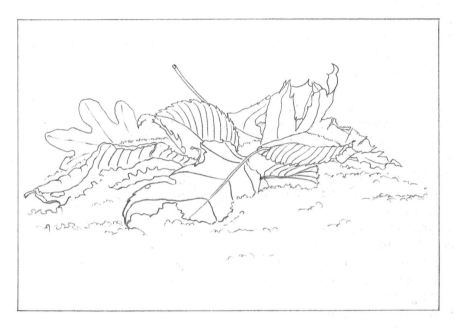

STANLEY MALTZMAN
Winter Leaves II
Graphite pencil on Whatman paper
18" × 22" (46cm × 56cm)

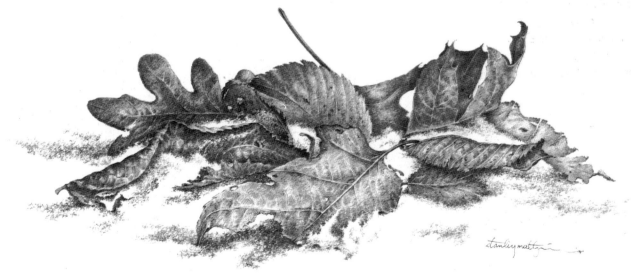

Watercolor Shadows on Snow

This technique is very sensitive to the brands of paper you use and your choice of color. It works best on a well-sized surface with artists' quality non-staining watercolor. The artwork on pages 82–93 was created by Zoltan Szabo.

On the dry shadow color use a small bristle brush loaded with clean water to remove the color and show patches of sunlight. To make the blurry edges, move the brush faster and for a shorter time, blotting off the floating pigments immediately.

Original shadow color

Wiped-off shapes

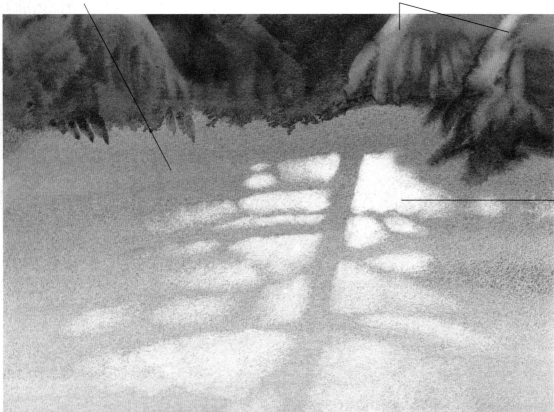

Islands of light shapes lifted out of wash of nonstaining colors

The snow surface was painted as if all of it were in shade, using Manganese Blue with a touch of Cobalt Violet on the dry paper surface. After the color dried completely, the shadows were treated as negative shapes. The sunlight shapes were removed by loosening the dry paint with a very wet, small oil painting brush and blotting it off with a bunched-up, dry paper tissue. This is the wet-and-blot technique. Note that the light patches are islands of white and the shadows were left untouched from the original wash.

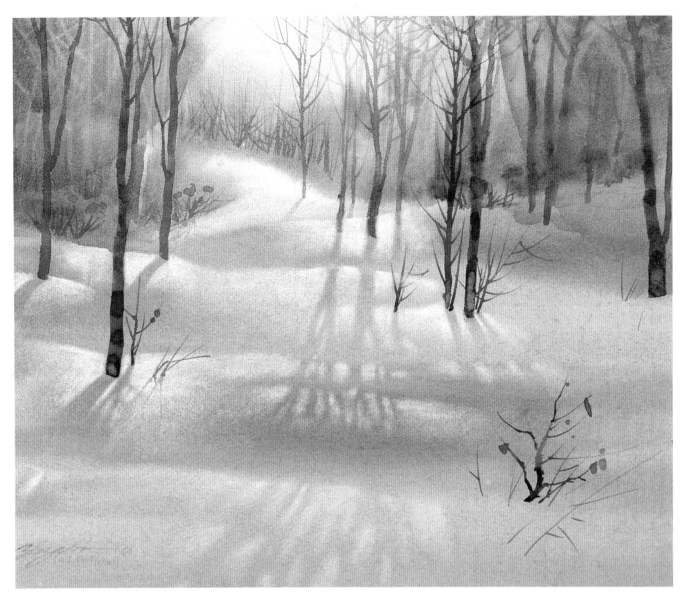

To lift the sunlight off the snow, a small bristle scrubber filled with clean water was used to loosen the pigment in a small area at a time, beginning at the top of the hill where the light is the strongest. The shadows are kept intact, lifting out only the islands of light. The edges of the shadows closest to the trees remain sharp, while the shadows extending into the foreground have softer edges and less contrast. Note that all the shadows taper toward the imaginary location of the sun.

ZOLTAN SZABO
Stoic Shadows
Noblesse cold-pressed paper
14" × 18" (36cm × 46cm)
Collection of Willa McNeill

Sunlight on Snow

Instead of the backlighting seen on the previous two pages, here you see strong front lighting on snow, sending the shadows away from you. The dark background color is made of charged lighter colors into a dark base wash. This must be achieved while the first neutral dark wash is shiny wet. Light colors replace dark colors easily when charged into very wet paint but behave unpredictably if the first wash sits too long. Play with charging colors. The bright foreground is left paper white except for the cool shadow and lone grasses.

Use a 1-inch (3cm) slant bristle brush for the dark dry-brush touches. The brush should be full of very dark color with very little water. For ideal results don't press the brush too hard or you'll get a lump. Barely touch the surface and the result will be free and lacy.

To scrape out the shapes of the light trees, use the oval tip of an acrylic brush handle. The color is applied in a rich consistency and scraped immediately. Hold your brush handles firmly between the thumb and fingers but allow the wrist to deliver the pressure.

To indicate bright sunlight, the dark background was painted leaving the large trees as negative shapes. The colors used were Cadmium Red-Orange, Rose Madder, Phthalo Green and Cyanine Blue in various dominance. The small tree trunks were created with the slanted end of an acrylic brush handle while the dark wash was still wet. After the first wash was dry, a glaze was used to create the shadows on the tree trunks as well as the little weeds and their shadows.

Wet-in-wet, warm dominated colors.

Untouched white paper

Cool shadows

Scraped out of wet background

Warmly Lit Snow

Painting warm light on a naturally cool subject is an interesting challenge. One technique is to first cover the area with a cool wash, lift most of it and then glaze with a warm color. When you glaze a warm color over a cooler shape that was scrub lifted, you are working over a slightly damaged surface. Make sure that your paper is bone dry, and cover the surface fast with a large, soft brush. Don't go back and forth or the surface may get mottled.

After lifting off shadow color dominated by Manganese Blue, Gamboge Yellow was glazed over the area to reflect the sky color.

Warm sky color

Original shadow color left after lifting.

First the golden sky was painted with a blended wash using a 2-inch (51mm) soft slant brush and a mixture of Gamboge Yellow and Rose Madder. The whole snowy hill was painted with the same blue color as the shadows and allowed to dry. The shadow colors are Manganese Blue with some Rose Madder. While this was drying, the dark evergreens were painted with a 2-inch (51mm) slant bristle brush using a strong mix of Manganese Blue, Rose Madder and a small amount of Phthalo Green. The large foreground area was scrubbed out, leaving the shadows untouched. Because the lifted color was too blue-white for the warm light condition, a very thin wash of Gamboge Yellow was glazed over the sunlit snow (including the shadows) to warm it up.

Falling Snow

There are various ways to represent falling snow in watercolor. This salt technique is a good one as long as it is used sparingly. There is only one trap with this technique, and it is timing. Sprinkle the salt just as the shine of your wash goes dull; you have about thirty seconds to do it. If you act too soon, the salt will dissolve and create ugly marks. If you put the salt on too late, nothing happens. The effect takes about fifteen seconds to start showing. Don't be impatient and throw in more salt. Too much salt is the kiss of death. Again, don't use salt all the time, only when the technique is necessary.

Carefully timed salt use created these snowflakes.

Dark shapes were painted onto an almost dry surface.

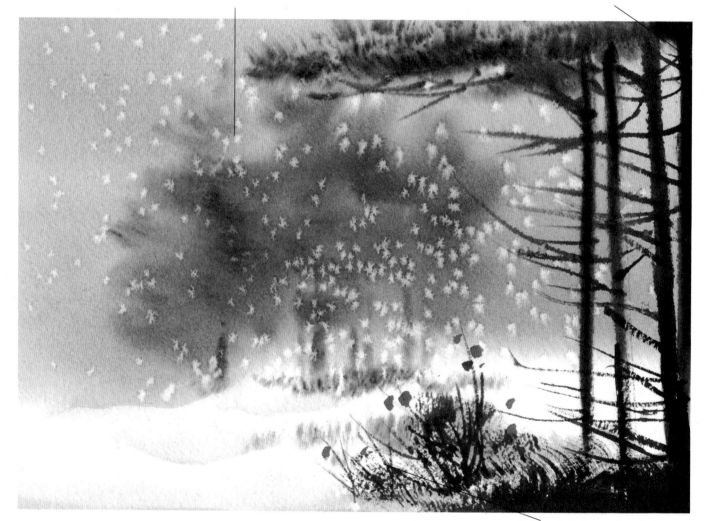

Dry-brush strokes were applied after the paper dried.

The moody background was painted with Burnt Sienna, Gold Ochre and Ultramarine Blue, using a 1-inch (3cm) slant bristle brush filled with rich colors and a little water on a wet surface. For the pines some Phthalo Green was added to the previous dark combination. Salt was sprinkled into the wash just before it lost its shine. Only a few grains of salt were used; more salt may create an overpowering blizzard effect.

Trees in Heavy Snow

Look for two areas of interest in this little color sketch. First, most of the washes are not only light in value but clean as well. Spontaneity is the reason for the smooth clarity of the colors. Second, the water droplets in the sky must be applied just as the shine of the wash goes dull. You may have slightly varying results each time, because it is impossible to match the timing to the split second. Expect the outcome to be fun, not perfection.

Sharp outside, soft interior definition

Water droplets spattered into damp wash

The colors used for the sky were Burnt Sienna, Cyanine Blue and Ultramarine Blue. A wash of Burnt Sienna and Ultramarine Blue was applied to the wet paper. The slant bristle brush was used to spatter a few water droplets into the drying color to hint of snowflakes. Then the silhouette of the snow-covered trees was painted. After the color dried, the few dark exposed branches were drybrushed on. The lost-and-found-edge technique was used for shading the snow on the trees as well as on the ground.

Young Spruce in Snow

The most important element in this example is also the most subtle one: shading the snow with lost-and-found edges. Sharp edges read clearer than soft ones. Whatever subject you paint, sooner or later you'll need to paint something that has a sharp edge on one side and a soft edge on the other. Any subject—a portrait, a figure, a landscape or an abstract watercolor—may use this technique.

Paint the delicate baby spruce branches sticking out of the snow immediately after dampening the dry paper. Use a no. 3 rigger filled with rich paint and very little water. As soon as the dark color touches the damp surface, it blurs a little to look like the fine needles of a spruce branch. It is important to apply the color with a delicate touch and just the right amount of moisture.

The blurry edge is the result of rich green brushed onto damp paper with a rigger brush.

Wet-in-wet area

Soft, blended lost-and-found-edge brushstrokes

The fine spruce branches were started on damp paper with rich pigment and a little water in a no. 3 rigger brush. The edges were allowed to soften slightly as the brush touched the damp surface. The snow was shaded with lost-and-found edges. Phthalo Green and Gold Ochre were used for the young spruces, and Burnt Sienna and a little Magenta were used for the snow. The cutting edge of a palette knife was used to indicate the thin weeds. The same colors are used in the background to create the sky and the soft trees.

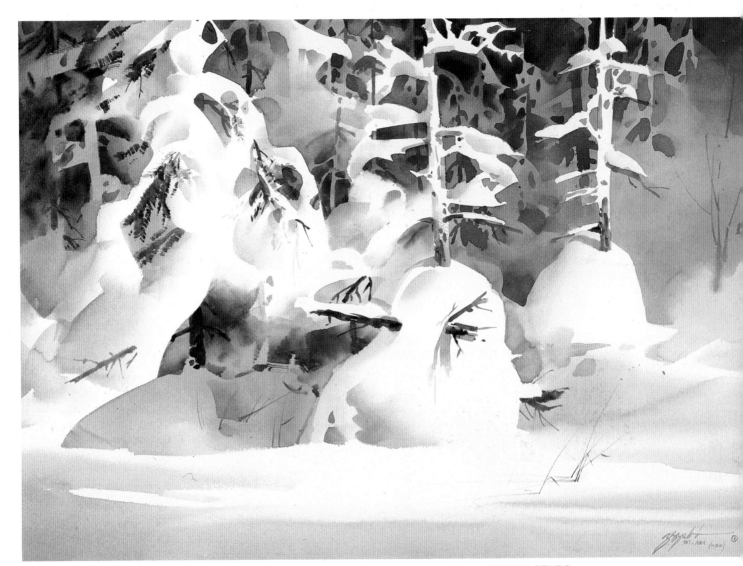

This winter scene is the result of several glazes and lots of lost-and-found-edge control on the snow modeling. A medium-value glaze was begun around the white snow. This color is still visible at the top right edge. As this was drying, the next darkest value was painted, exposing the silhouette of the shaded trees in the value of the first wash. The darkest glaze at the top came next followed by the random branch structure creating dark accents. The snow humps were shaded by applying the shadow colors and blending away the edges facing the sun. This lost-and-found-edge technique makes the snow look soft, deep and inviting. The reddish bark complements the otherwise cool dominance of the painting.

ZOLTAN SZABO
Winter Friends
Watercolor
15" × 22" (38cm × 56cm)
Collection of Tom Malone and Susan Pfahl

Ice on Trees

Timing is very important for this exercise. As the dark background wash loses its shine, go as fast as you can with a little water in your small rigger brush and paint the frosty branches. Echo the general shape of the trees, not just the branches. You have only about twenty-five seconds to paint the frosty branches on the sketch. Poking at it after the paint has dried won't help. Catch it fast when the time is right, then walk away.

Dark background painted
onto wet surface

Clear water stroked
into damp color

Green charged into
wet gray wash

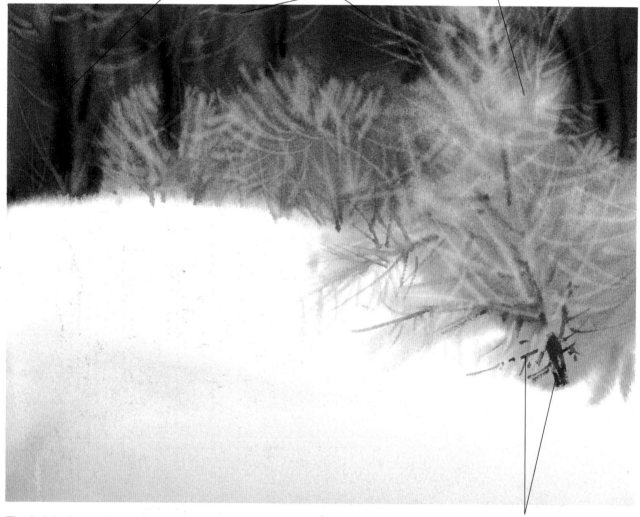

Darks painted after
background has dried

The dark background was painted onto a wet surface using Magenta and Phthalo Green, which promptly neutralized each other. As the wash began to lose its shine, the ice-covered branches were painted using a small rigger to apply clear water in a fast repetitive way, creating rhythmical branch shapes. In the lower right, where the branches reach the white snow, the combined colors of Magenta and Phthalo Green were again used with the rigger brush to paint the pale gray frosty branches against the still-moist white background. After the paper dried, the few sharper dark branches at the base of the closest tree were added.

Frost on Trees

Controlled back runs are a very effective but seldom used extension of the wet-in-wet watercolor painting style. Use them to loosen up your paintings. Feeling is your only guide for these very free shapes. The fast application and the timing are so crucial that you watch the evolution of the tree shapes while you build the back runs with water droplets.

Back runs formed by clear water dropped into drying damp wash

Dark lines painted into wet wash

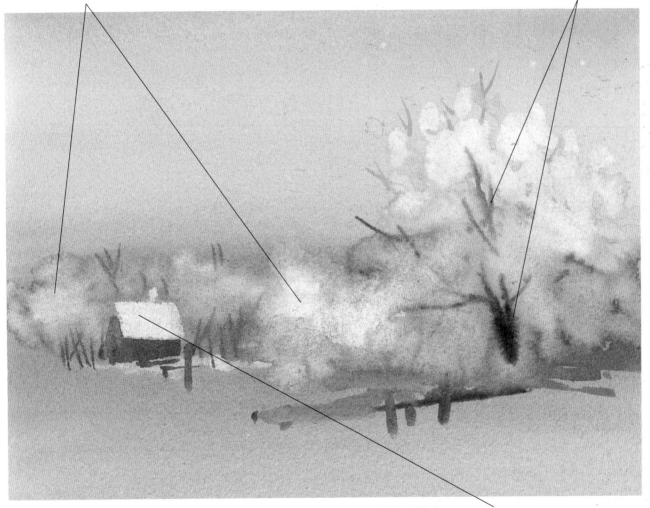

Lifted white shape

The whole surface was painted on wet paper starting at the top with Cerulean Blue. A little Gold Ochre was added next to the lower sky and followed with a heavy wash of Burnt Sienna and Ultramarine Blue. This wash was blended a bit lighter as the wash continued downward to the bottom edge of the paper. After about a minute, as the wash started to dry, small drops of clear water were sprinkled onto the paper with the rigger brush to create the frosty looking back runs. A few tree trunks, branches and the distant log cabin were painted into the almost dry shapes to give the scene a little sense of reality. The white snow on the roof was removed with the wet-and-blot technique after everything had dried.

Mist

Even though the wash for the trees was painted with a staining color (Sepia) and allowed to dry, it was safer to apply the blended mist color on top of it with a half-loaded large brush rather than going back and forth many times, risking some possible loss of the Sepia wash. When the wet slant brush has paint only in the long-hair end of it and just water in the short hairs, it will blend one side of the brushstroke and leave the other end dark and sharp to read as a strong design element.

Dark glaze on top of dry mist color without blending with it

Cobalt Blue and Titanium White glaze

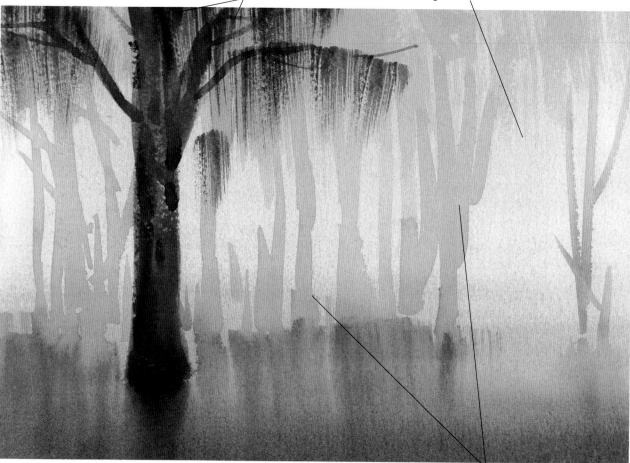

Sepia washes

On a dry surface, a very light wash of the tree trunks was roughed in with Winsor & Newton Sepia (a staining color). After this wash was dry, a mix of Cobalt Blue and a little Titanium White was glazed on using a 2½-inch (60mm) soft slant brush. This wash was thicker at the top and more diluted near the bottom of the trees. The long-hair end of the brush held the thicker paint, and the shorter hairs supplied the water simultaneously. This way the brushstroke blended its own edge as it was applied. Again the paint dried completely. The dark tree with the Spanish moss was gently glazed on with a ¾-inch (19mm) flat aquarelle brush without disturbing the dry mist color.

For this example, white was not used in the color mix for glazing the mist. Cobalt Blue, a light opaque color, was used. Diluting an opaque color with water is like adding white paint. Water makes watercolor lighter by diluting it. The staining color of the background wash visually combines with the semiopaque Cobalt Blue wash, showing the translucency of both colors. You can use this technique with any combination of opaque and staining colors on any subject where you want to create a soft misty effect. Remember, the strength of the colors is determined by how much water and paint are in your brush.

Graded Cobalt Blue top glaze Sepia underwash

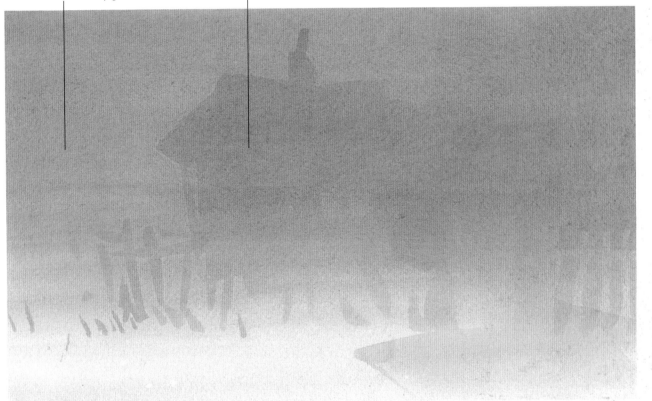

The silhouette of the building in the background was applied with a faint wash of Winsor & Newton Sepia and allowed to dry. The mist wash was glazed on top of it with a 2½-inch (60mm) soft slant brush loaded with Cobalt Blue at its long-hair end but only water in the short hairs. As the artist repeatedly moved the brush horizontally, the value of the wash got darker at the top but stayed lighter at the bottom.

A Wooded Snow Scene

JOSEPH ORR

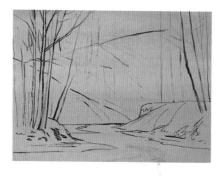

1 MAKE A PRELIMINARY SKETCH
Working from thumbnail sketches, do a brief painted sketch on your canvas.

2 COMPLETE THE SKETCH (ABOVE)
Use a wash of diluted Ultramarine Blue and Titanium White to avoid a harsh glare from the white of the canvas. Draw in the basic outline of the composition with diluted Burnt Umber. The sketch is not detailed—you only need the basic idea. This allows ample opportunity for creative maneuvering as the painting progresses.

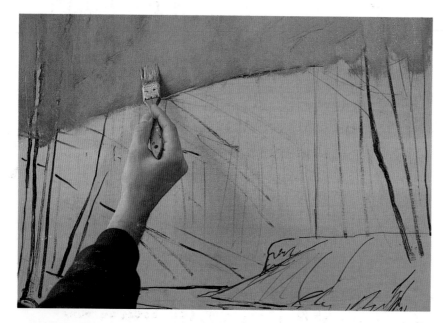

3 BLOCK IN COLOR (LEFT)
Block in large portions of color, working from the top of the canvas to the bottom using a 1-inch (25mm) white bristle brush.

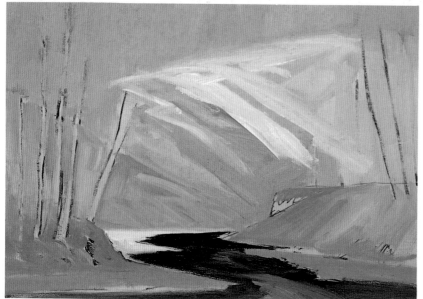

4 FINISHING BLOCKING IN COLOR (LEFT)
Don't be concerned with staying inside lines, but only with establishing color patterns within the composition. Use mixtures of Ultramarine Blue, Phthalocyanine Blue, Dioxazine Purple, Mars Black and Titanium White in different portions depending on light or dark areas. Since this is a snow scene, start with cool colors. Add some Hooker's Green in your mixture for the dark water of the stream. Even at this stage texture is already beginning to emerge.

5 PLACE BACKGROUND TREES

After blocking in, place the background trees. This is done with a worn no. 1 round bristle brush using a mixture of Ultramarine Blue, Burnt Umber and Titanium White. Notice how the brush is held with the thumb and index finger and used in a quick downward stroke to achieve the impression of distant trees.

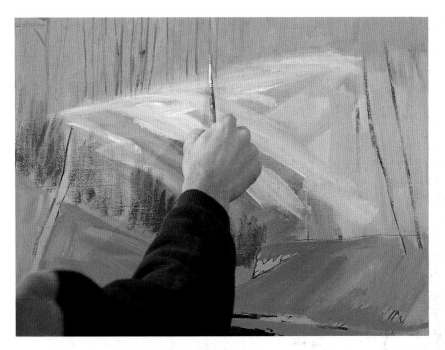

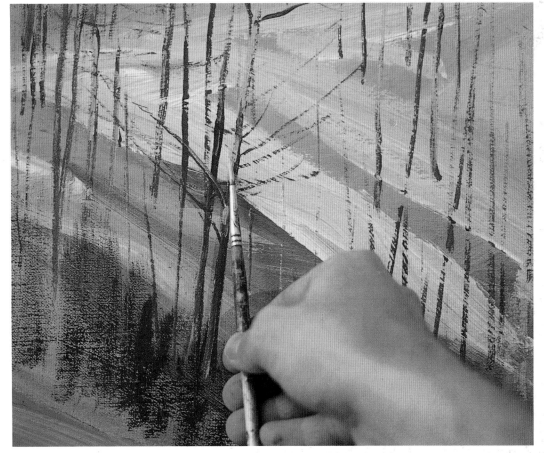

6 PAINT HIGHLIGHT

Detail: Paint in highlights on some of the trees by loading the brush and dragging it in a downward stroke, magically giving the illusion of rough texture on the tree bark. For highlighting, use Yellow Oxide, Burnt Sienna and Titanium White.

7 USE A DRY BRUSH

Paint in the underbrush of the forest with the same 1-inch (25mm) white bristle brush you used for blocking in the first stages of the painting. Use a dry-brush technique with a mixture of Titanium White, Yellow Oxide, Burnt Umber and Dioxazine Purple.

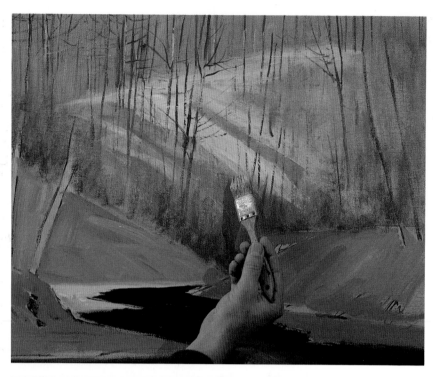

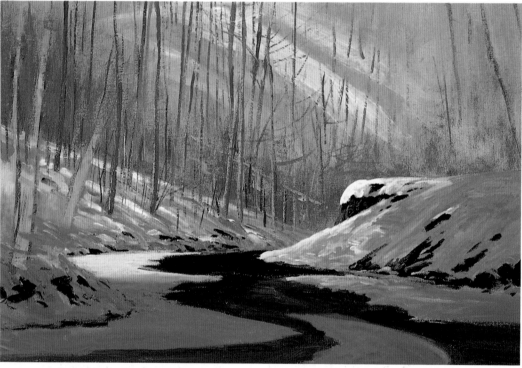

8 USE SHORT STROKES FOR HIGHLIGHTS

By using quick, short strokes, highlight the ground where the sunlight is reflected, giving the illusion of deep snow. For this, use nos. 1 and 2 white bristle bright square brushes and a no. 1 round bristle brush. The colors for these intense highlights are Light Portrait Pink, Cadmium Orange and Yellow Oxide, each mixed with Titanium White and applied individually. This gives the work a sense of the direction of light and varying color in the snow, reflecting the surroundings. At this time, you can also add a few bigger trees in the middle ground.

Thick Pigment for Texture

Using a lot of pigment for the bright highlights automatically creates texture on both the snow and the rocks.

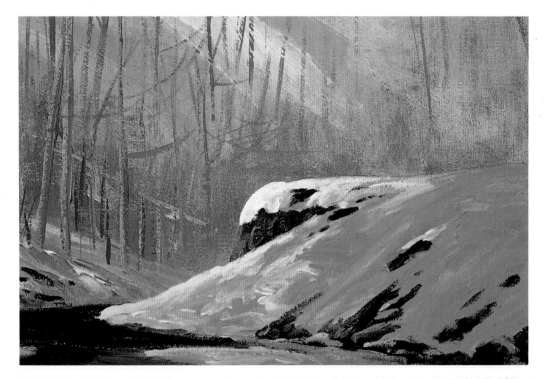

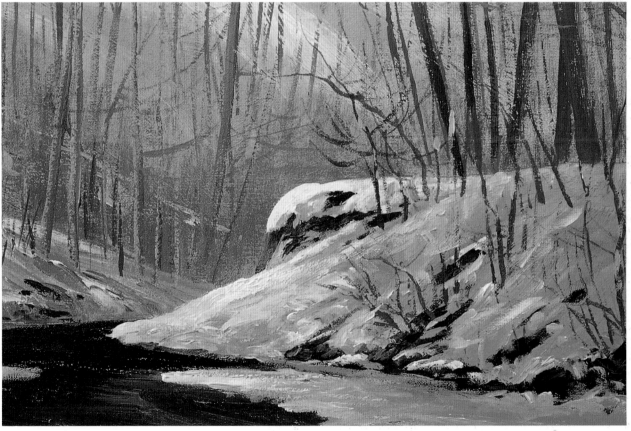

9 CREATE MORE TEXTURE

Detail: Notice the emergence of texture on the right side of the painting, due to a generous use of pigment. Add the tall dark trees and brush twigs coming up through the snow.

10 DEFINE THE CENTER OF INTEREST

Detail of the left side: A more intense sense of light filtering through the trees from left to right will strengthen the composition and make a distinction of the center of interest. Paint a light area using the dry-brush technique behind what will become the foreground trees. Use Yellow Oxide and Light Portrait Pink, both mixed with Titanium White.

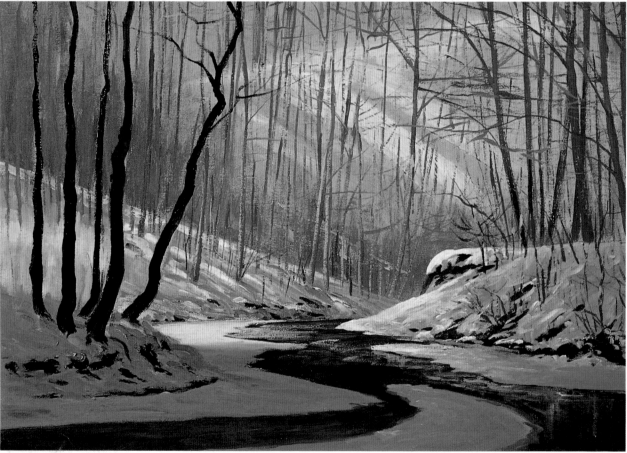

11 CREATE DRAMA

Now paint the foreground trees in shadow. Put the light color behind these trees first, and then paint them in a dark color to heighten the drama of the entire panting.

Close-up of the trees in shadow on the left side

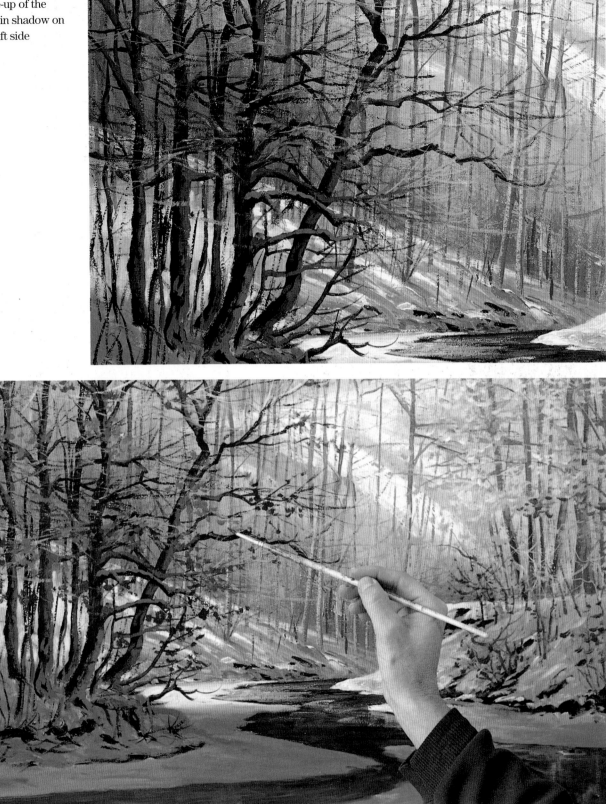

12 ADD WARMTH

Some oak trees have their leaves all winter, which is great for artists. They give a sense of movement to the scene and allow for the addition of warm colors. Colors for shadowed leaves on the left: Burnt Sienna, Burnt Umber, ACRA Violet and a touch of Cadmium Orange. Colors for sunlit trees on the right: Yellow Oxide, ACRA Violet, Cadmium Orange and Cadmium Yellow Light, all mixed with Titanium White.

13 SPRAY VARNISH

Lightly spray two small areas with spray varnish to add snow texture.

Detail

Close-up of shadowed area on the left side of the painting where the spray varnish technique is used

Detail

Use the spray varnish technique on the small branches of the twigs that are around the rock outcropping to simulate clinging snow.

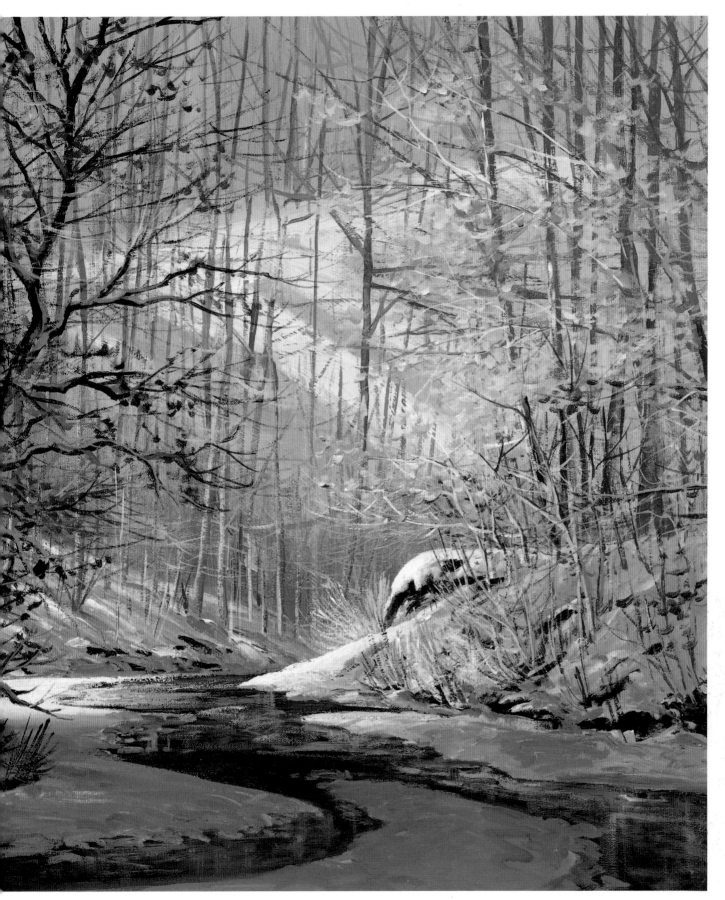

JOSEPH ORR
Hollow Secrets
Acrylic
22" × 28" (56cm × 71cm)

Painting Trees "En Plein Air" & "En Studio"

Nature and You

Artist's moods vary as often as the moods of nature, so your own feelings about subjects come into play. Choose subjects that attract and inspire you. Try to express qualities of nature that touch you personally, trusting your intuition more than formulas and pre- conceptions. Be sensitive to your sur- roundings. Let yourself be like a child: curious, full of wonder and imagination. Your painting is part you and part the scene. The artwork on pages 102–103 was created by Kevin Macpherson.

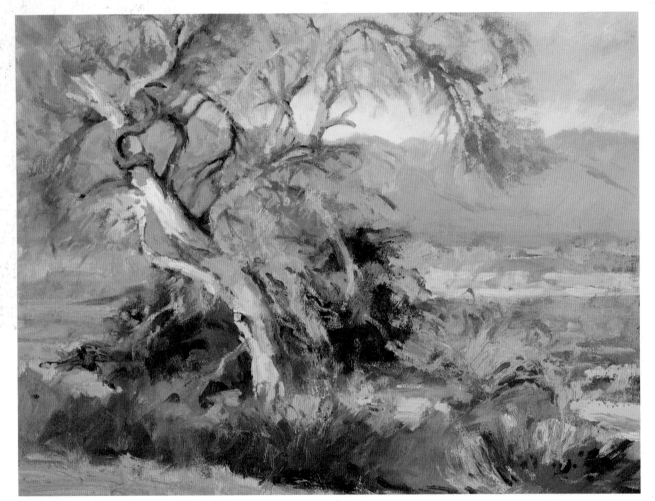

The Spark
Listen to this lone tree speak. The rhythm created by its struggle with the desert elements and by the warm glow of the desert light is intriguing. People will often lead you to a beautiful scene that must be painted, but it is not the scene as much as the colors, values and shapes that combine for an emotional response from the artist.

KEVIN MACPHERSON
Scottsdale Sunset
Oil
16" × 20" (41cm × 51cm)

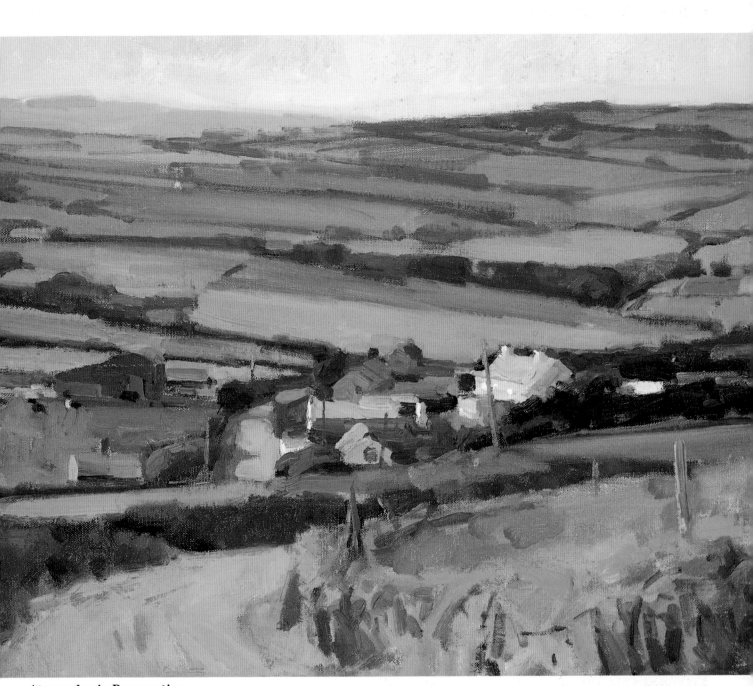

Atmospheric Perspective

In the foreground, textures and warm colors advance. The illusion of depth is enhanced by overlapping elements, less value contrast, and colors neutralizing into atmospheric blue-grays as they go deeper into space. Think of the atmosphere as sheer curtains. Because the air is dense with moisture particles that reflect light, as things recede into the distance, there are more veils of atmosphere to look through. The more layers there are, the less you can see. If you paint what you see, comparing shapes to each other, you will automatically get the feeling of atmospheric perspective.

KEVIN MACPHERSON
Emerald Pastures
Oil
16" × 20" (41cm × 51cm)

Tip Texture comes forward.

En Plein Air in Winter

KEVIN MACPHERSON

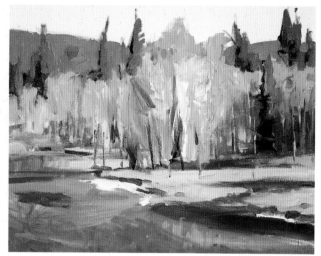

1 A FREER START
As you progress and become more accurate, you may want to lay in more freely. However loosely you choose to paint, maintain the shapes of the shadows.

2 COVER THE CANVAS
Cover the canvas as quickly as possible, without worrying about finishing any one area. Be concerned with the big color notes.

Tip Work all over the canvas at the same time.

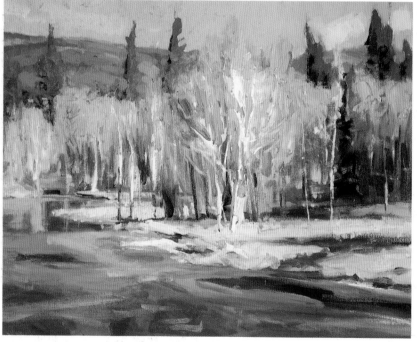

3 CARVE OUT THE DRAWING
With your major shapes blocked in, carve out the branches and add variation to all the shapes. If the light changes, stick to your original plan.

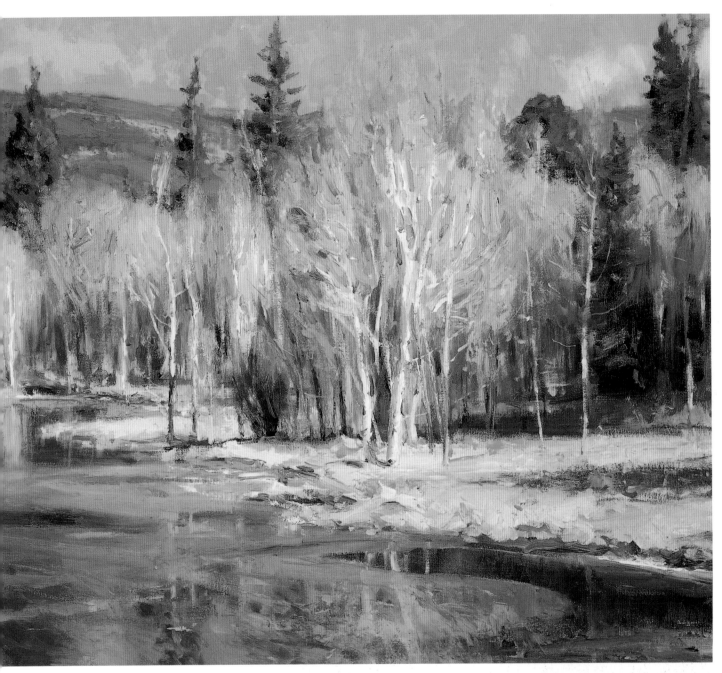

4 FINISHING TOUCHES

Stepping back helps you visualize your painting more objectively. The evergreens were mimicking each other; one became smaller and more rounded. A hint of snow in the background hills helps add movement and space by repeating the foreground snow color.

KEVIN MACPHERSON
Icy Pond
Oil
24" × 30" (61cm × 76cm)

Tip Did you convey your idea, concept, mood?

A Snow Scene From a Photograph

WILLIAM HOOK

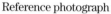
Reference photograph

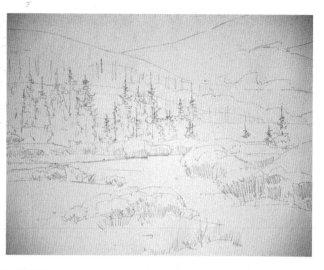

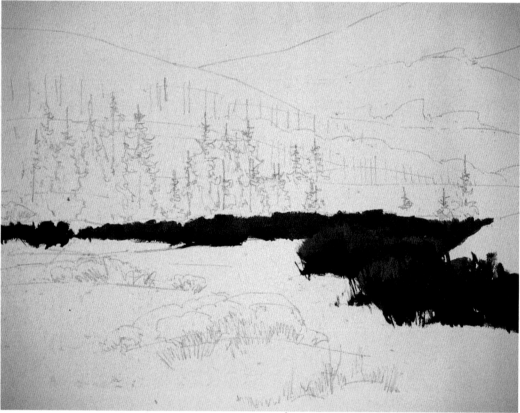

1 ROUGH SKETCH (ABOVE)

Sketch out the subject to give yourself reference points on the canvas. This enables you to avoid any guesswork that might slow the painting process. Acrylic paint dries quickly; this is good for working quickly, blending paint on the canvas while the paint is completely wet.

2 PAINT THE MIDDLE GROUND

Typically, you should start a painting in the middle ground. Blend as much of the blocked-in subjects as you can. If you do not overpaint the entire canvas, much of the blended paint will be visible in the finished work. The colors of the willows are mixed from Dioxazine Purple and Naphthol Crimson. Burnt Sienna is used to tone down areas, while Cadmium Red Light is used to highlight areas.

3 BLOCK IN QUICKLY

Block in the sections that have similar hues. To paint the evergreens, mix a large quantity of wet green colors on the palette. Paint quickly, and finish blocking in the evergreens before the paint dries on the palette. The same is true of the red willow pigments and the more neutral colors of leafless aspen trees.

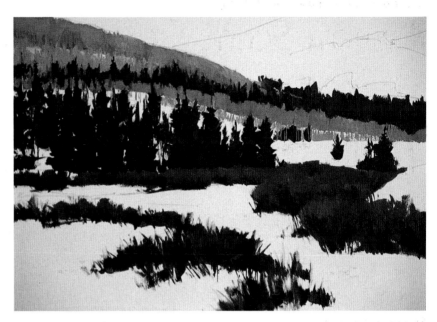

Detail

This detail shows how two painted subjects (aspen trees and evergreen trees) are blocked in next to one another. By using a larger brush (no. 10 synthetic bright), you can apply paint in a fairly quick manner. This helps blend larger areas and inhibits any desire you might have to prematurely add detail to the painting. The evergreens are made from Hooker's Green, Phthalocyanine Green, Burnt Sienna, Permanent Green Light, Yellow Oxide and Ultramarine Blue. The aspen trees are painted from white, Yellow Oxide, Medium Magenta and Permanent Green Light.

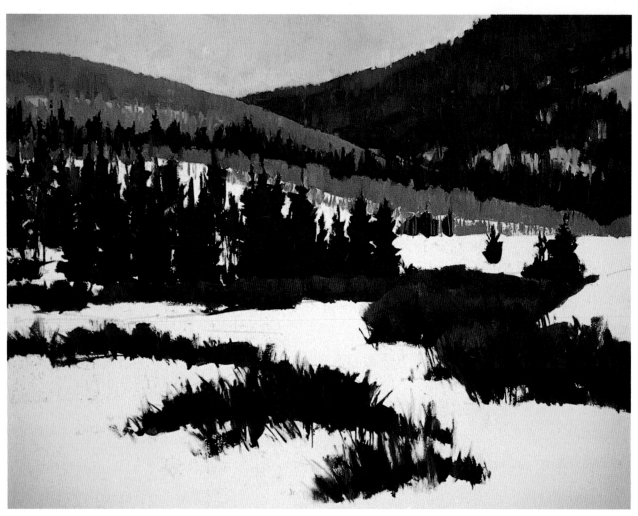

4 ACHIEVE SPONTANEITY

In a snow scene like this one, allow the white of the canvas to simulate the snow so you can continue to paint the distant ground. Spray the section that will become distant trees with a fine mist of water to facilitate the application of paint over a larger area. The spray also helps the pigment stay wet on the canvas while you add detail by blending hues and brushing on paint in the vertical direction of the trees. The spontaneity and directness achieved during this process will remain in the finished painting.

Tip PAINT OUTDOORS FREQUENTLY

The secret to natural looking studio paintings is to spend as much time as possible out of doors observing all of the fine details of nature. It also helps especially to have as much experience as possible painting outdoors, even if only quick color sketches.

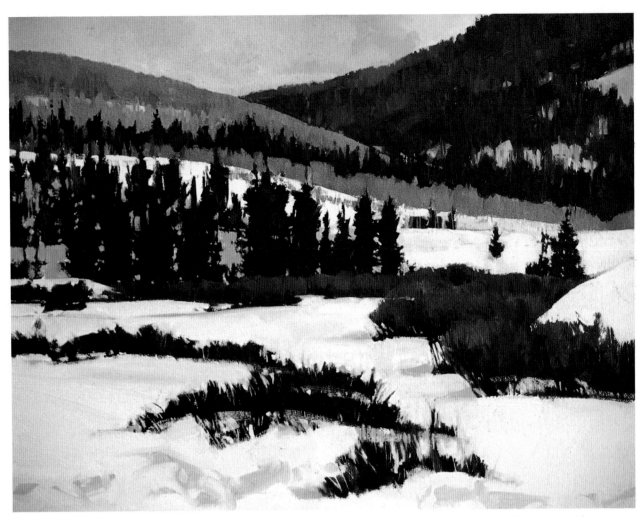

5 ADD SNOW

Now paint the white of the canvas with a very similar hue. Spray the entire canvas with a fine water mist before brushing in the snow. The snow will help shape and design the trees and willows. While the paint is wet, add detail to the snow by mixing in shadow color. The snow color is slightly grayed with Medium Magenta and Permanent Green Light. This creates a neutral value that will allow bright highlights to be added in contrast at a later time. Paint the sky with a bit of blue showing through. This blue will be an undercolor only and will show through in the finished painting.

Tip PAINTING SHADOW
The secret to painting shadow is in the amount of bounced light you see in the shadow itself. A dark, contrasting photo will never work. Study the light at the time you photograph and recall that mental note when painting.

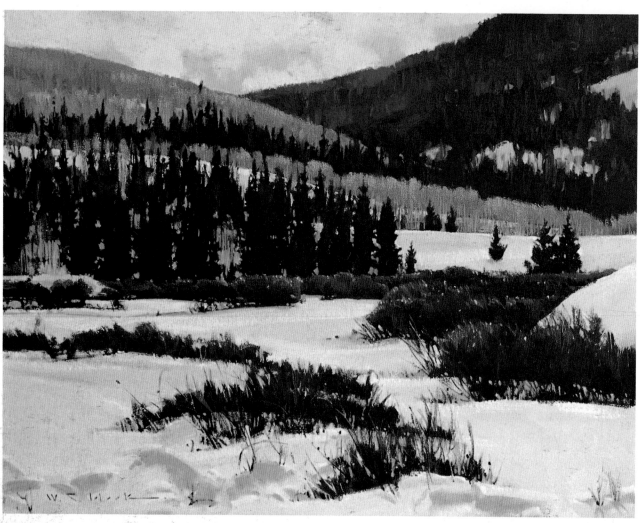

6 FINISH

Until this point, you have used mainly layering and dry-brush techniques. Now, the sky changes from the previous step due to the layering of lighter valued pigment. By doing this, you are able to change the mood of the entire painting. More highlights and details are added. The finished painting combines many techniques; however, impasto is achieved through light strokes of paint with no additives.

WILLIAM HOOK
Winter Patterns
Acrylic
24" × 30" (61cm × 76cm)

Tip **DRY-BRUSH DETAILS**
Dry-brush details are finishing touches that will make the painting come together. A contrasting light pigment works best in the sunlit areas, while darker values are natural in the shadowed areas.

Detail

Layering was used for the painting of negative space between the evergreen trees. In the shadow areas, Medium Magenta and Ultramarine Blue are mixed with white. No water is used. This allows single brushstrokes to diffuse, or soften, the edges of the subjects being overpainted.

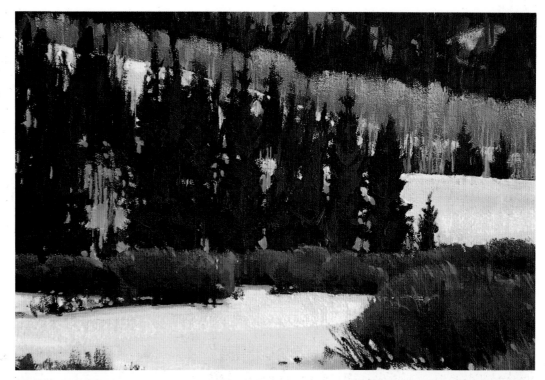

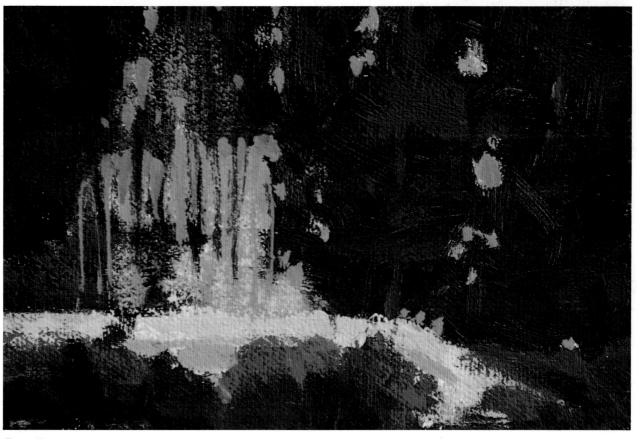

Detail

Following the painting of the negative areas, use the edge and corner of a no. 8 bright brush to render the narrow trunks of trees. Overpaint these trunks on either side in order to give an irregular look of a tree and not simply a brushstroke.

Sunlight Penetrating a Morning Fog

GIL DELLINGER

On a visit to the French countryside, Artist Gil Dellinger awoke to find a morning fog. In a few minutes the light was penetrating through the fog, hitting the village buildings and some old abandoned orchard trees. This was painted on-site.

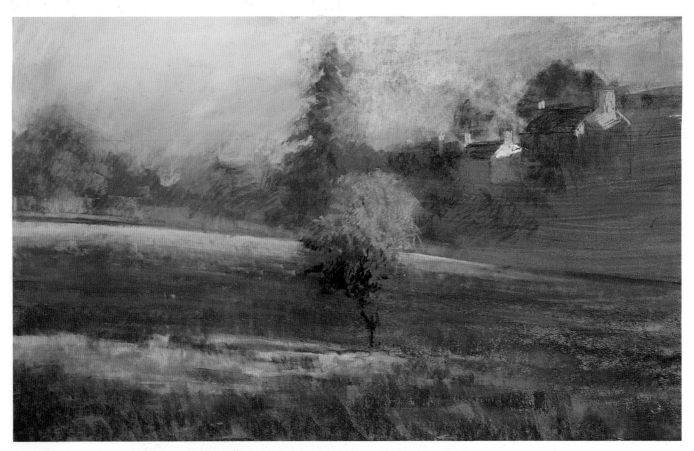

1 LIGHT AND SHADOW SHAPES (ABOVE)

Rough in the general shapes of light and shadow on Wallis pastel paper primed with Dark Gray acrylic. Use a heavy concentration of Golden airbrush acrylic and a wide brush to prime the paper. You can see the color of the acrylic primer on the center right. Let some paper show through to help maintain unity.

Detail of Step 1 (left)

The first color laid down while roughing-in is not always the finished color. An undertone of bright orange or yellow can create the look of sunlight. Lay down Nupastel Naples Yellow in the sky. As you approach the finished colors it will be covered and will underlay the gray fog to create an illusion of sunlight seen through the mist.

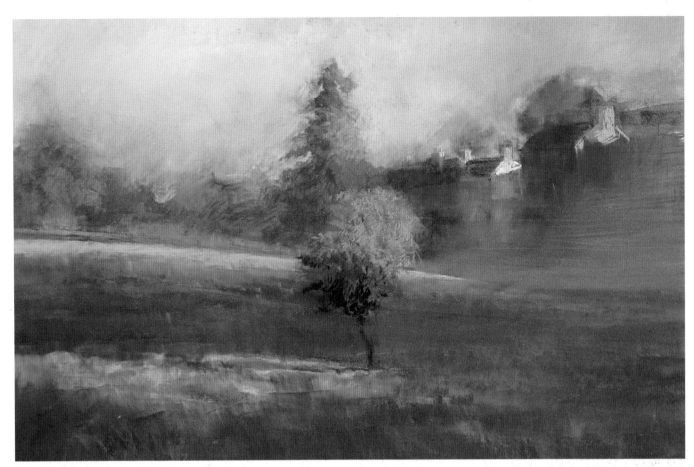

2 CREATE DEPTH

Creating space is the number one concern here. Blend all the initial colors from step 1 using a piece of packing foam. Add pastel to the foreground so the values are stronger. Add more high-key background values to soften the buildings in the mist.

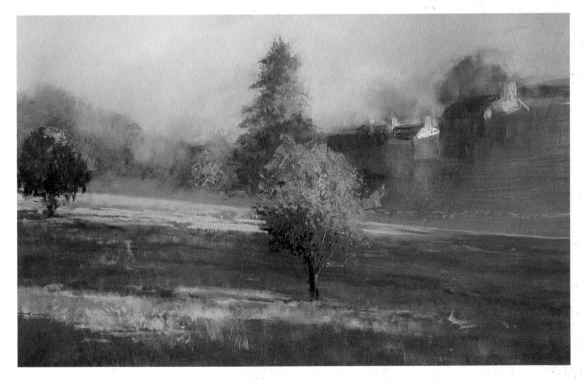

3 BALANCE THE COMPOSITION

Add a tree on the left to balance the composition and help define the space. Blend the colors as needed, but the remainder of the picture will be strokes only.

4 DARK UNDERCOLOR

Lay down some dark color as an underlayer for the lighter strokes of grass to come.

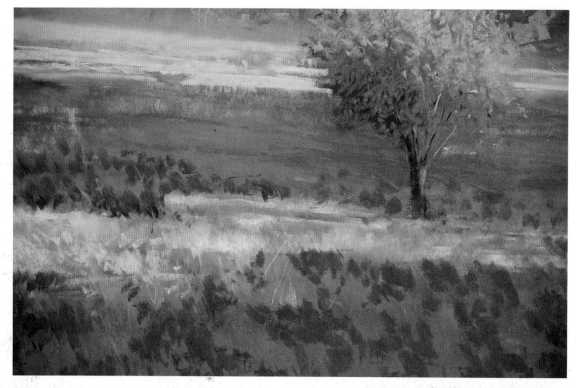

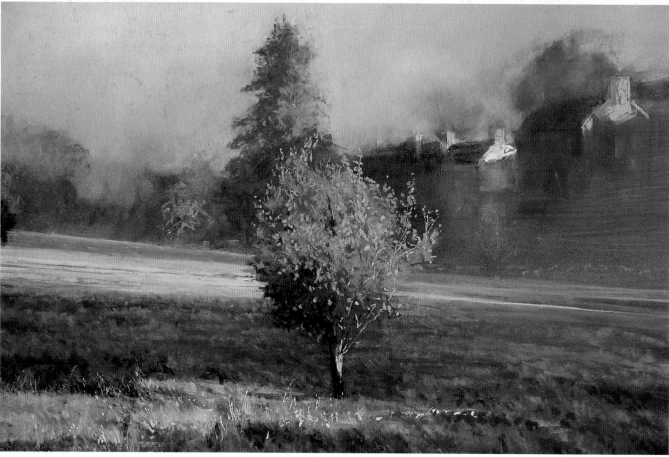

5 STROKES OF BRILLIANT LIGHT

Add bright, clear strokes to indicate light hitting the tree and grass. Don't do any blending here. These strokes of light set the mood and become the focus of the painting.

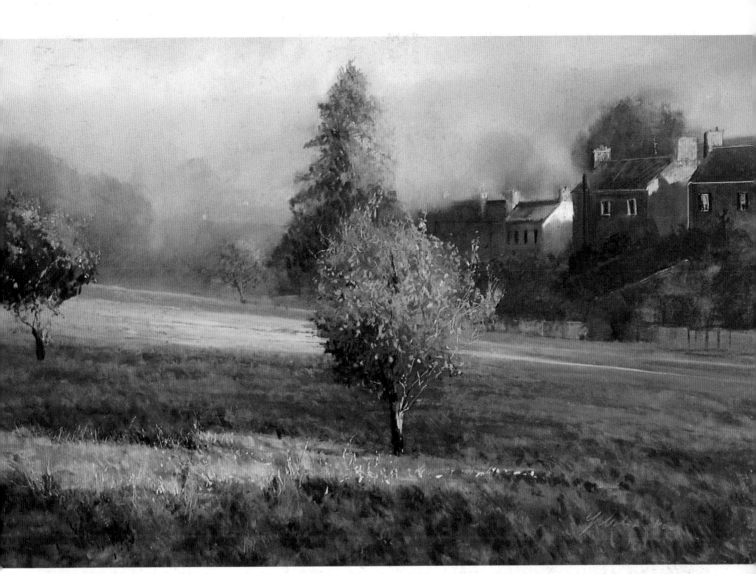

6 FINAL TOUCHES

To finish, add background detail on the right. Add detail to the houses hit by light, and soften some trees back in the mist. Notice that the mist changed by lightening a section at the top to indicate a hillside shrouded in fog.

GIL DELLINGER
Morning Fog at Balleroy
Pastel
24" × 36" (61cm × 91cm)

Tip KEEP PASTELS OPAQUE TO MAINTAIN THEIR SPARKLE

Quite the opposite to watercolor, which is at its most luminous when it is transparent, pastels glow only when kept cleanly opaque. For that reason, save the most sparkling lights for last, so the pure pastel pigment sits undisturbed and opaque on top of previous layers.

Mood Changes From the Outdoors to the Studio

Autumn Stand began with an idea painted on a small canvas on location. Brad Faegre will often alter the mood of a painting when recreating a scene en studio. The mood expressed in the finished painting differs significantly from his preliminary study. The artwork on pages 116–117 was created by Brad Faegre.

On-Site Study: A Warm, Peaceful Mood

The artist was greatly affected by what he was seeing. Surrounded by warm colors and noting the subtle atmospheric changes that occur in late afternoon, this small painting has the peaceful, almost lazy, quality that the warm, glowing light produces late in the day as the sun dips to its resting place. It is easy to sense the original feeling of the place from this study: There is a subtle peacefulness as warm light reflects from every surface.

Tip BE BOLD AND DON'T FEAR MISTAKES

Go with the mood of the painting. Be inspired by nature, but go with your instincts. The great thing about acrylics is that change is relatively easy.

Studio Finish: A Mood of Alert Anticipation

Curiously, the finished painting took on its own (different) mood as soon as the colors were mixed, first on the palette and then on the canvas. By painting the sky first, it quickly became the most interesting part of the painting. In fact, it is the primary interest. It seemed to call for bright colors and more intense value contrasts. The movement in the brushstrokes in the sky, coupled with the darker values and brighter colors, implies that something is about to happen, in contrast to the peaceful feeling of the study. The glow of unified light that appears in the study is not there. The light seems to be undergoing a change before our eyes. Is a storm brewing? Or is the wind clearing the clouds away?

BRAD FAEGRE
Autumn Stand
Acrylic
20" × 24" (51cm × 61cm)

Oil Sketches Become Studio Paintings

Often, it is very helpful to paint en plein air, or on location, even if you only use this painting sketch as a basis for a larger, more detailed studio painting. The combination of several photographs for detail and a painted sketch for color and mood should give you all the information you need for a natural looking studio painting. Pages 118–125 show Kevin Macpherson's oil sketches alongside each studio painting of the same subject.

KEVIN MACPHERSON
Fall Bullion
Oil sketch painted on location
6" × 8" (15cm × 20cm)

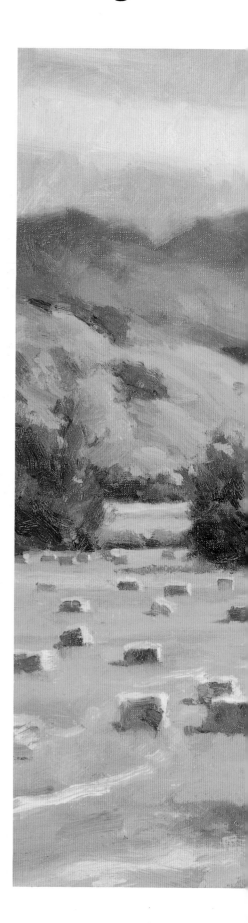

Rethinking a Composition
Once in the studio, the composition was reconsidered. The Teton Peak was too centered and close to the top of the painting, so the cloud cover was added and the colors intensified. By removing the landmark, the piece gained a more universal appeal.

KEVIN MACPHERSON
Fall Bullion
Oil
20" × 24" (51cm × 61cm)

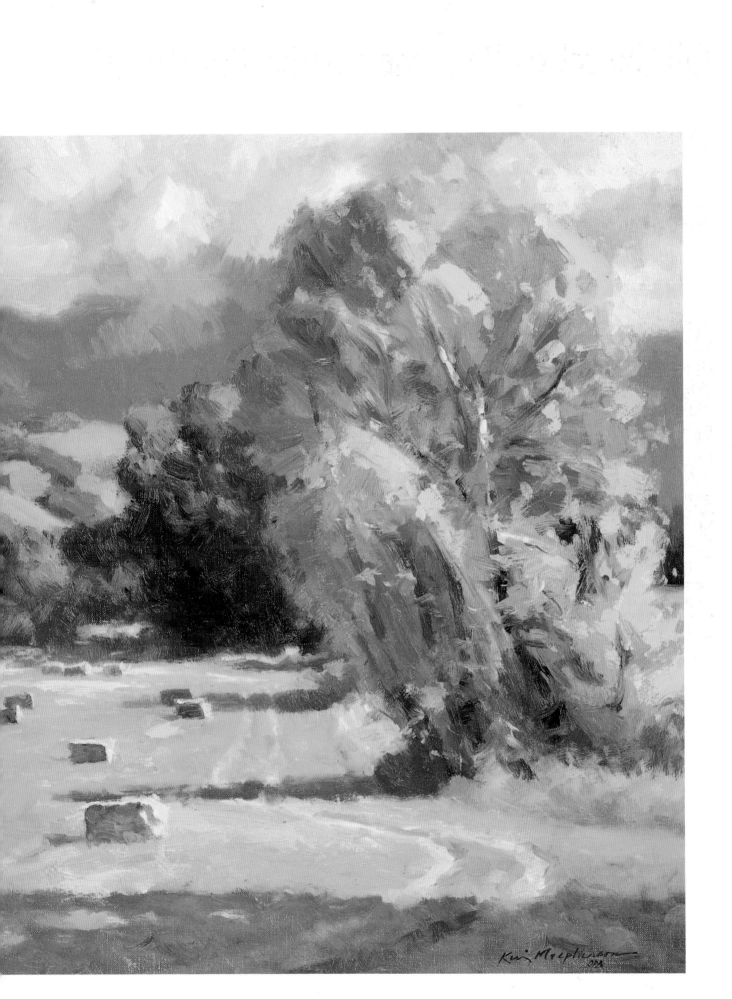

RETAINING FRESHNESS

The larger studio version of this scene was done almost exclusively from the 6" × 8" (15cm × 20cm) color sketch. Plastic horses kept in the studio helped in visualizing their forms. The dark trees contrast with the airy quality of light on the distant mountains. The addition of snow on the mountains helps the eye move from foreground to background.

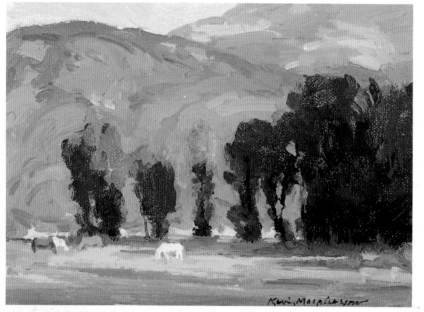

KEVIN MACPHERSON
Long Morning Shadows
Oil sketch painted on location
6" × 8" (15cm × 20cm)

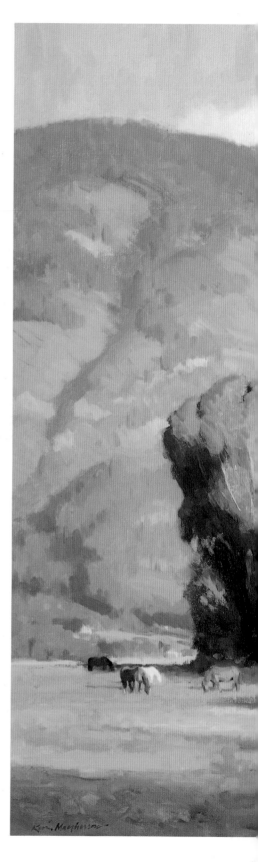

KEVIN MACPHERSON
Long Morning Shadows
Oil
40" × 50" (102cm × 127cm)

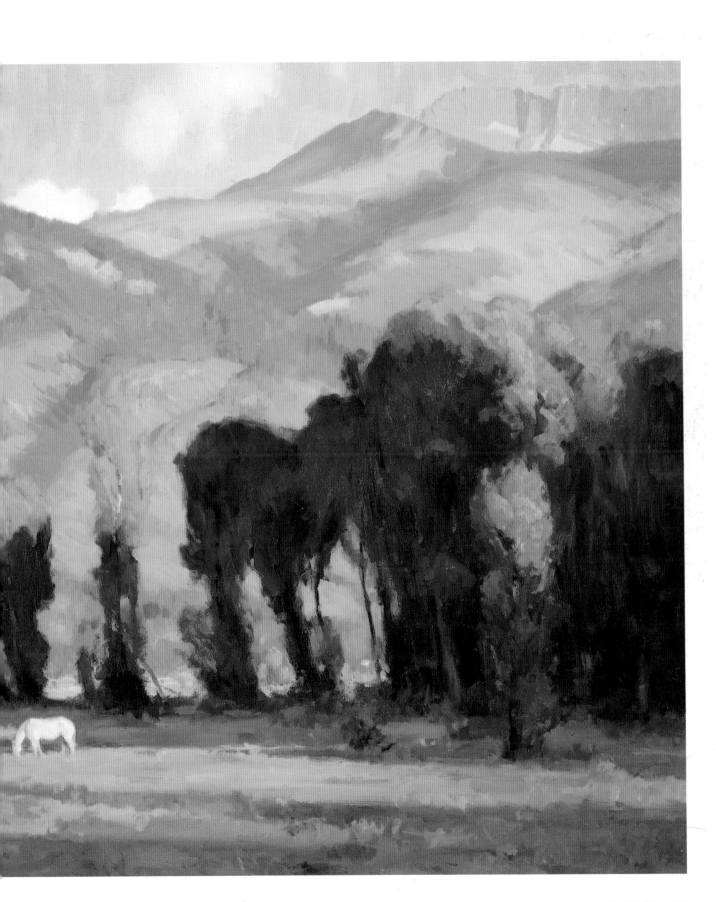

MEMORY AND ANTICIPATION

On March 7, 1993, the full moon rose at its closest point to the Earth in over a century. This was a perfect subject for a painting. After witnessing this occurrence, a color sketch was made back in the studio on a 6" × 8" (15cm × 20cm) panel. Pleased with the memory study, a larger composition was begun, laying in the major masses of color. Knowing that the scene would change quickly, the artist went out again the next day, this time prepared to capture that moon and its warm light on a larger format. The scene itself gave all the information needed for the final painting.

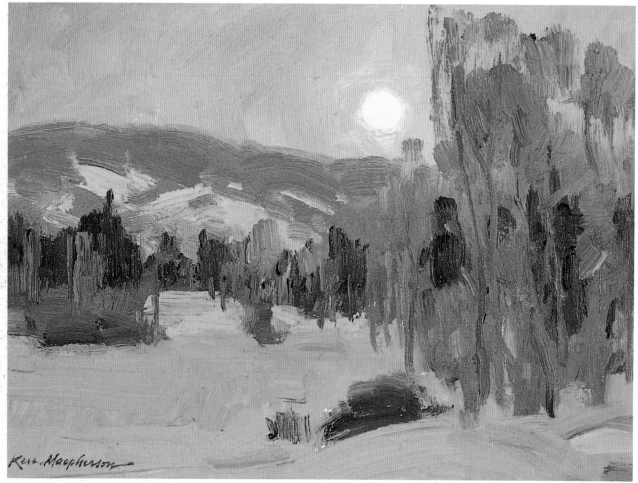

KEVIN MACPHERSON
Full Moon Rising
Oil sketch painted on location
6" × 8" (15cm × 20cm)

Tip Be responsible for your growth. Work hard. Rewards will come.

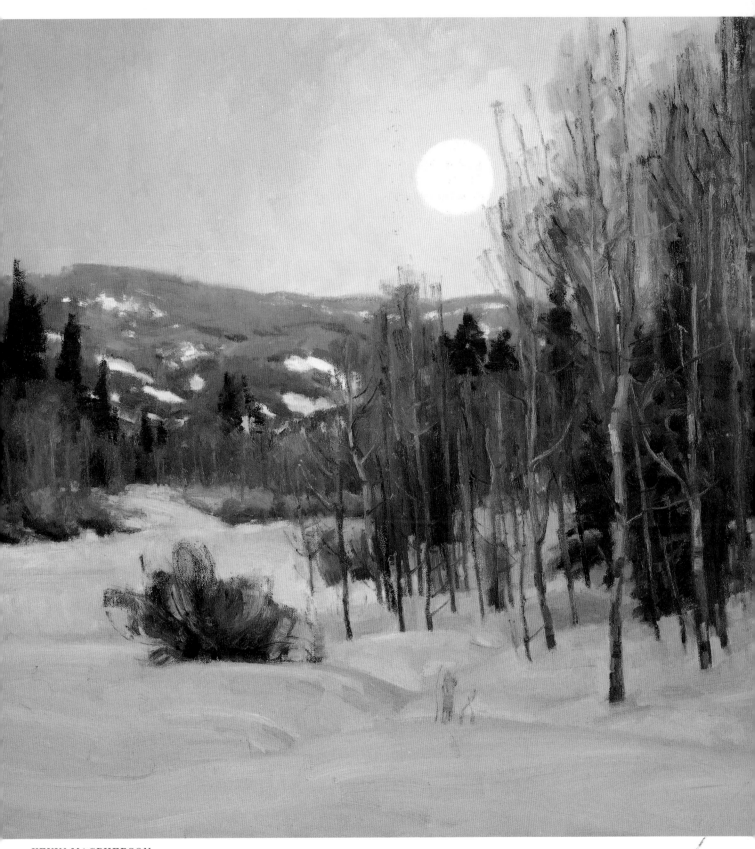

KEVIN MACPHERSON
Full Moon Rising
Oil
24" × 24" (61cm × 61cm)

THE FEEL OF THE OUTDOORS

This pochade was done on location in
Bishop, California. The brilliant greens,
the cloud-filled sky and the light beam-
ing over the mountains were all caught
in the small painting. The color sketch
provided the proper color harmonies
necessary to work on the larger studio
painting in addition to a photo reference
for the gestures of the grazing sheep.
Using the photo reference and the paint-
ing reference, a large studio painting
that feels like it was painted outdoors
was created.

KEVIN MACPHERSON
Grazing Below the Mountains
Oil sketch painted on location
6" × 8" (15cm × 20cm)

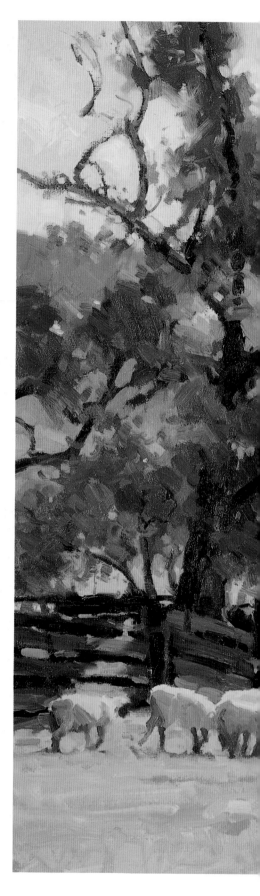

KEVIN MACPHERSON
Grazing Below the Mountains
Oil
30" × 36" (76cm × 91cm)

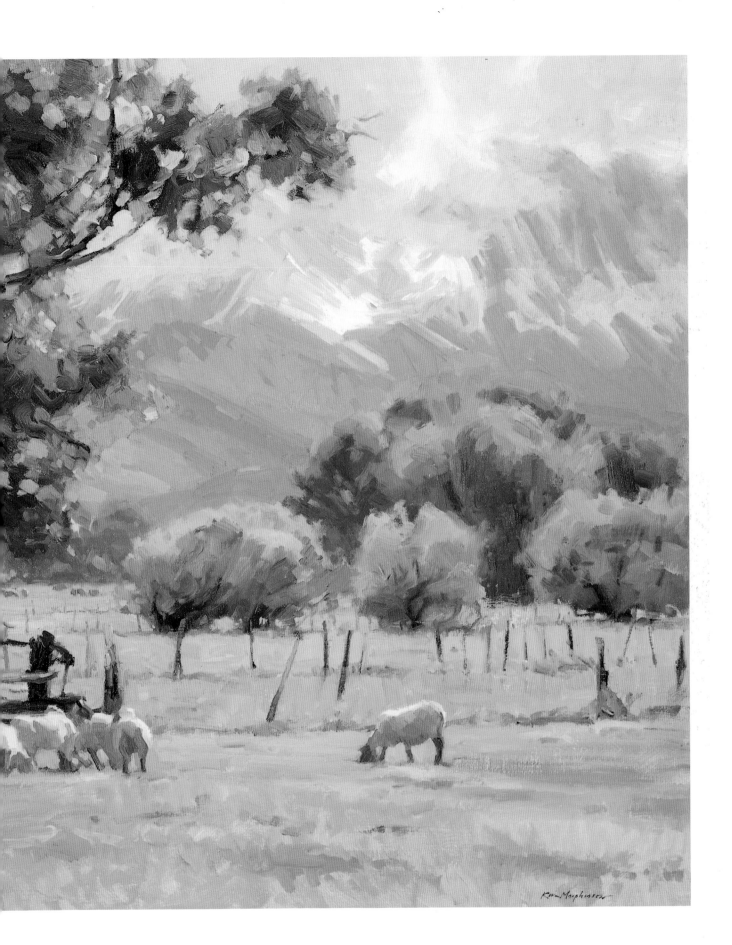

INDEX

A

Abstract paintings, 35
Acrylics, 57, 106–111
Alcohol ring, 64
Angular buildup, 13
Aspen trees, 54–55, 107
Autumn leaves, 11, 44–51, 116–117

B

Background
 dark, 90
 scraping wet, 84
 spray paint, 36
 trees in, 32, 95
Balance, 20, 113
Bare trees, 17, 28
Bark, 24
Birch trees, 34–35, 40–45
Birds, flying, 77
Blending, 16–17
Blocking in, 30, 94
Brayer, 41–42
Brushes
 bright, 111
 fan, 25, 61
 fine, 24
 flat, 61, 92–93
 liner, 61
 rigger, 41, 88, 91
 round, 23
 soft slant, 85, 92–93
Buildings
 cabin, 73, 91
 farm, 66–69, 103
 in mist, 113
 in silhouette, 93

C

Canvas, toning, 30
Carpenter's pencil, 10, 15
Cattails, 18
Cedar, 23
Center of interest, 98
Charcoal
 powder, 16
 soft vine, 76
 values of, 10
Charcoal pencil, 10–11, 74–75
Charging watercolors, 46–48
Circular shading, 12, 81
Collage, correcting with, 40–43
Color palette, 29
Colors
 blocking in, 94
 bright foliage, 56
 complementary, 54–55
 nontraditional, 35
Complementary triads, 55
Contour drawing, 81
Criss-cross pen work, 61
Cross-hatching, 14

D

Daffodil leaf, 59
Depth, 103, 113
Desert, tree in, 102
Drawing
 carving out, 104
 contour, 81
 techniques, 8–21
Dry-brush technique, 22–24, 28, 58, 68, 86, 96, 110

E

Edges, softening, 33
Elm, 23
En plein air, 104–105
Evergreen tree, 23, 79, 85, 106–107.
See also Pine tree; Spruce tree

F

Fence, 13
Ferns, 62–63
Fields, distant, 61
Fog, 112–115
Foliage
 autumn, 44–51
 in bright colors, 56
 complementary colors for, 54–55
 mountain, 15
 See also Leaves
Foreground
 textures in, 103
 trees in, 98
Frost, 91

G

Gloss medium, 41
Glue, 41
Gouache, 69
Graphite pencil, 10–11, 70, 74–75, 79, 81
Grasses, 25, 60–61, 66–73
Greens, 26–27, 52–53

H

Highlights, 33, 69, 95–96
Horizon line, 20–21
Horizontal format, 18
Horses, 120–121

I

Ice
 on pond, 105
 on trees, 90

L

Lake, 18–19
Layering, 71, 73, 111
Leaves
 autumn, 44–51
 dry, 12
 negative print of, 62
 pen and ink, 58–59
 snow on, 80
 tropical, 57
 underpainting, 46
 veining in, 48–51
 winter, 80
 See also Foliage
Lichen, 64
Light
 painting, 66
 sparkles in, 34
 See also Sunlight
Liquid frisket, 34, 64. See also Masking fluid
Locust tree, 79
Lost-and-found-edge technique, 87–89

M

Mask
 liquid frisket, 34, 64
 paper towel, 37
 for spray paint, 38
Masking fluid
 applying, 66
 removing, 67–68, 72
 with ruling pen, 70
 See also Liquid frisket
Mist, 92–93, 113
Mixed medium, 36–39
Modified triads, 55
Mood, setting, 33
Moon, rising, 122–123
Moss, 62–63
Mottling, 59
Mountains, 16
 in autumn, 118–119
 distant, 120–123
 foliage on, 15
 sheep grazing below, 124–125
 tree-covered, 78
Mushrooms, 65

N

Nasturtium leaf, 59

Natural sponge, 37, 41
Negative space
 in birches, 35
 in evergreen trees, 111
 in grasses, 68
 in rocks, 73

O
Oak bark, 24
Oak fern, 63
Oak trees, 23, 99
Oil paint
 mountain scenes in, 30–33, 118–119
 winter scene in, 104–105
Orchard, 56

P
Palette knife, 41, 88
Paper
 preparing, 69
 for texture, 34
Parsley leaf, 59
Pastels, morning fog in, 112–115
Pasture, 103
Pen, ruling, 66, 70
Pencils
 carbon-based, 76
 carpenter's, 10, 15
 charcoal, 10–11, 16, 74–75
 graphite, 10–11, 70, 74–75, 79, 81
 holding, 8
 mechanical, 10, 13
 values with, 10–11
 water-soluble, 10
 woodless, 10
Pen and ink
 leaf textures, 58–59
 stippling, 63
Photo reference, 106, 124
Pine needles, 13
Pine tree, 8, 14, 30–33, 86. *See also* Evergreen
tree
Pond, frozen, 28–29, 105
Poplar, 23
Poppy leaf, 59
Prairie, golden, 25

R
Reeds, 66–73
River bank, 31
Road, 20
Rocks, 9, 16, 73, 97
Rose leaf, 58
Ruling pen, 66, 70

S
Salt, 63, 86
Saral transfer paper, 40
Shading, 12–13
Shadows
 bounced light in, 109
 cool, 84
 evergreen, 85
 foreground trees in, 98
 on leaves, 50
 on snow, 83
Sheep, 124–125
Shoreline, 16, 18–19
Sketch, preliminary, 94
Sky, dark, 90
Snow
 backlighting on, 82–84
 evergreens in, 106–107
 falling, 86
 heavy, 75, 87
 in landscape, 76–77
 on leaves, 80
 light, 74
 light sparkles of, 34
 rocks in, 97
 in shade, 82
 shadows on, 83
 soap powder model for, 80
 sunlight on, 82–84
 texture in, 35, 97
 on trees, 79
 warmly lit, 85
 in woods, 94–101
 young spruce in, 88
Spanish moss, 92
Spattering, 25, 35, 61, 64
Sponge, 37, 41, 60–61
Spray painting, 36–39
Spray varnish, 100
Spruce tree, 88
Stippling, 28, 63
Stomp, 16–17, 76
Stream, 97–101
Studio painting, 106–111, 116–117
Subject, simplifying, 33
Sunlight
 bright undertone for, 112
 brilliant, 114
 morning fog and, 112–115
 on snow, 82–84
 on water, 31
 See also Light

T
Tearing, 40
Texture

 in foreground, 103
 paper used for, 34
 in snow, 97
Thumbnails, 18–19
Toning the canvas, 30
Tortillions, 16
Tracing paper, 40, 81
Tree bark, 24
Tree shapes, 22–23
Tropical leaves, 57
Twigs, 22

U
Undercolor
 bright, 112
 dark, 114
Underpainting, leaves, 46

V
Value, 10–11, 48
Vertical format, 18–19

W
Water
 bright, 31
 reflections in, 9, 19
 rocks and, 16
 See also Lake; Pond; River bank;
Shoreline
Watercolor
 autumn leaves in, 44–51
 falling snow in, 86
 grasses and reeds in, 66–73
 mist in, 92–93
 shadows on snow in, 82
Water spatters, 35
Weeds, 25, 60–61, 88
Wet-and-blot technique, 82–83, 91
Wet-in-wet technique, 22, 28, 61, 91
Wild plum bark, 24
Willows, 106–107
Winter
 bare trees in, 28–29
 frost in, 91
 icy pond in, 104–105
 leaves, 80–81
 mist in, 92–93
 tree-covered mountains in, 78
 woods, 11
 See also Ice; Snow
Woods, 9, 11, 94–101

Unlock the Secrets of Great Painting!

In this book, top artists share proven techniques for painting portraits, distant figures, bustling crowds and more. It's some of the best step-by-step instruction ever published by North Light Books—from how to use light, composition and color effectively to full-length painting demonstrations. No matter what your medium or painting experience, these keys will help you unlock new levels of expression in your faces and figures.

0-89134-976-6, paperback, 128 pages

Nothing creates a stronger sense of "life" in your wildlife art than realistic textures. This book, a collection of some of the finest art instruction ever published by North Light Books, will show you proven ways to paint fur, feathers and other realistic wildlife textures. You'll find easy-to-follow instruction and step-by-step demonstrations from top wildlife artists in a variety of mediums, including acrylic, oil, watercolor and pastel.

0-89134-914-6, paperback, 128 pages

More than any other single element, light can bring drama, emotion and power to your paintings. Find out how with this invaluable guide, filled with proven techniques and easy-to-follow instruction from top artists. These pages hold some of the best step-by-step instruction ever published by North Light Books—from creating lively sunlit effects to designing strong compositions using light and shadow.

0-89134-931-6, paperback, 128 pages

Discover the tricks to creating realistic textures from twelve expert artists! This book features beautiful art and clear, easy-to-follow demonstrations in a host of mediums. Step-by-step, you'll learn how to achieve the look of elegant lace, rusty metal, luscious fruit, sparkling crystal, jagged rocks, delicate porcelain and many other surfaces. No matter how long you've been painting, these textural secrets will help bring your paintings to life.

1-58180-004-5, paperback, 128 pages

Buildings are more than bricks and boards—they have stories to tell. In these pages, you'll discover a range of techniques for painting expressive "portraits" of your favorite homes and buildings—from cottages and barns to mansions and cityscapes. This is some of the best instruction ever published by North Light Books, covering everything from perspective and composition to how to paint stone, brick, wood and other textures step-by-step.

0-89134-977-4, paperback, 128 pages